www.dirtypilot.com

YEAR ONE REWIND

A Survey of Graffiti, Street and Urban Art

WHAT IS (DIRTY PILOT?), AND WHY DOES IT EXIST?

I began DP because galleries aren't the most customer-friendly businesses, and I wanted to help change that. There had to be a way for people to see new art – and buy it – in an easier fashion. Not everyone is spooked at the thought of walking into a gallery, but enough people definitely are that it made me want to try a new way. I've been on every side of the process: as an artist exhibiting my work; as a swanky Newbury Street gallery owner in Boston, and through it all as a collector of incredible artwork that I'd never want to sell for any price.

Web sites break down so many of those barriers, so I wanted to use dirtypilot.com to reach some of these new audiences. The web is open 24 hours a day and isn't hidden in some odd part of town. There's no pressure and nobody either staring at you or obviously ignoring you. But most importantly, dirtypilot.com is a place where people can learn about a group of artists whose work I love and am passionate about, as well as make a purchase if they're so inclined, whether of artwork, clothing, prints or other items DP sells.

That said, on to the artists and their work. This collection here represents some of my favorite artists, not only for the work they make but for who they are as people and for the roles they play in their respective genres. It's an honor and a pleasure to work with them all.

I've loved and collected Chris "Daze" Ellis' work for more than twenty years. He's been a great friend and adviser as well as a constant source of artwork that I want for my own. His pairings of letters and characters capture his New York and mesh graffiti and fine art effortlessly, because he's been doing it for thirty years. Ghost and Cern are both renowned graffiti writers in their own right as well. Justin Bua's figurative work captures the hip-hop spirit as well.

The graffiti movement has opened the door for a host of new artists that work in media that sprung out of it. Paper Monster's intricate stencil work and Greg Gossell's collages bring to mind the layers of posters and images that pile up on city streets in popular, readily viewed locations. Albert Reyes' work, on the other hand, feels private and personal, as though he was opening up a treasured blackbook full of sketches and works both finished and left half-done.

Similarly, Kime Buzzelli and Daniel Johnston's drawings have that giving quality – you can practically see them pouring their guts out onto the pages late at night. Michael Kruger's work has the appearance of a sketchbook page as well, but is in fact a carefully considered mixture of hand drawn work with lithography and digital processes. Dennis McNett's work recalls old woodcut illustrations in two tones. And Stephen Tompkins' cartoonish drawings mix familiar imagery like Dr. Suess appendages and Disney fingers with characters that are entirely his own.

Enrique Martinez makes mixed media landscapes and scenes that blend collage and a pop surrealist sensibility. And Bravo Jett's photorealistic pop art brings it all back full circle to me, recalling James Rosenquist, who was one of my favorite artists early on.

Dirty Pilot is proud to present this collection of work from these artists, and we hope that you'll take the opportunity to visit the site to see more of their work and the work of many other artists. And say hello when you do.

ALAN BORTMAN

CHRIS STAIN

SHOW DATES
OCT 18 – NOV 20

"I grew up in Baltimore in the 80's. Through books and movies I was introduced to NYC subway graffiti which sparked my interest in art, making it a viable means of self expression for myself. In high school I learned screen printing methods which would later aid me in the process of stenciling. I have always been sensitive to my surroundings and the struggles of common working people. With my work I hope, at best, to inspire compassion in people who hold positions of power to effect change in the lives of the less fortunate"

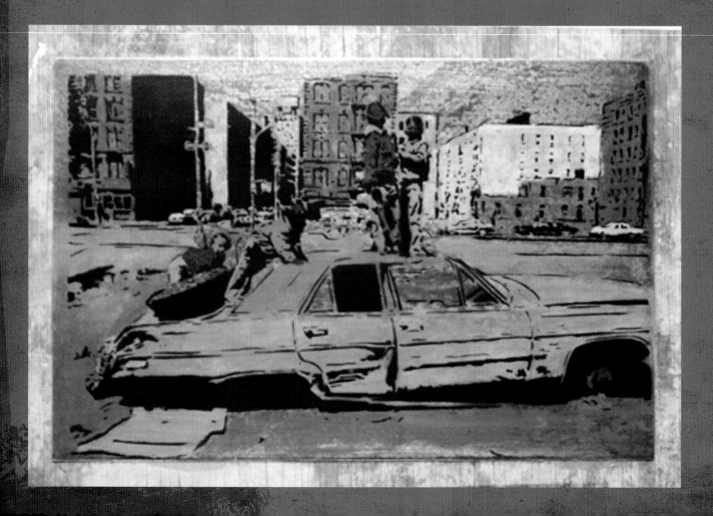

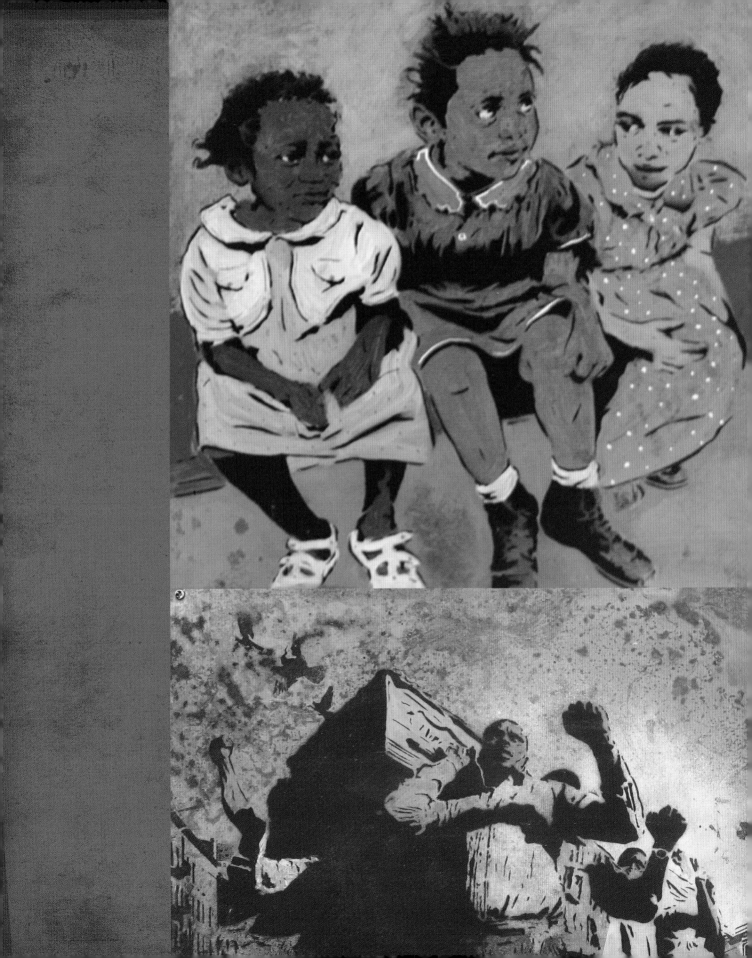

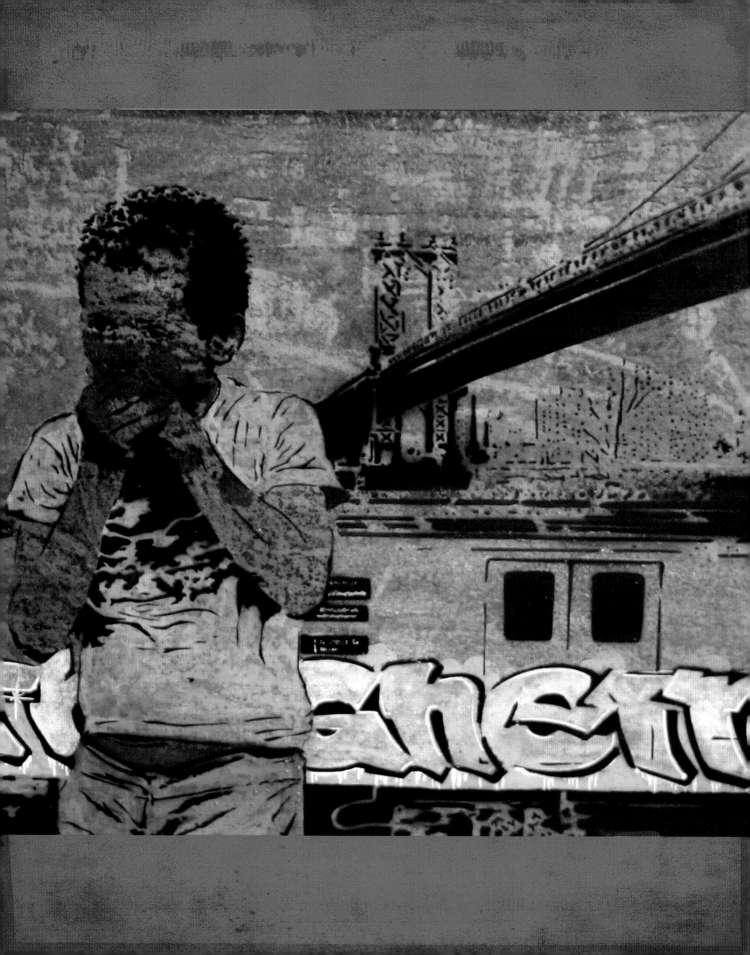

ALBERT REYES

SHOW DATES
APRIL 24 - MAY 26

Albert Reyes has been known to spit art on his hands and knees with a mouth full of beer in the middle of the street. He has also shown in a gallery along with a painting by Picasso. These same strange dualities and juxtapositions are highly prevalent in his work, which tackles both conceptual and graffiti art. Recognized for his ubiquitous "GIVE" tag, Albert has a distinctive artistic approach inspired not only by street art, comic books, and American pop culture; but also by contemporary and classical "high art". Reyes has exhibited worldwide. He has done album cover artwork for the band Le Rev and singer/songwriter Simone White. He has also appeared in the New York Times: Year In Ideas, Swindle, Chicano Art Magazine and appeared on Jimmy Kimmel Live, CW's Online Nation, and CNN.

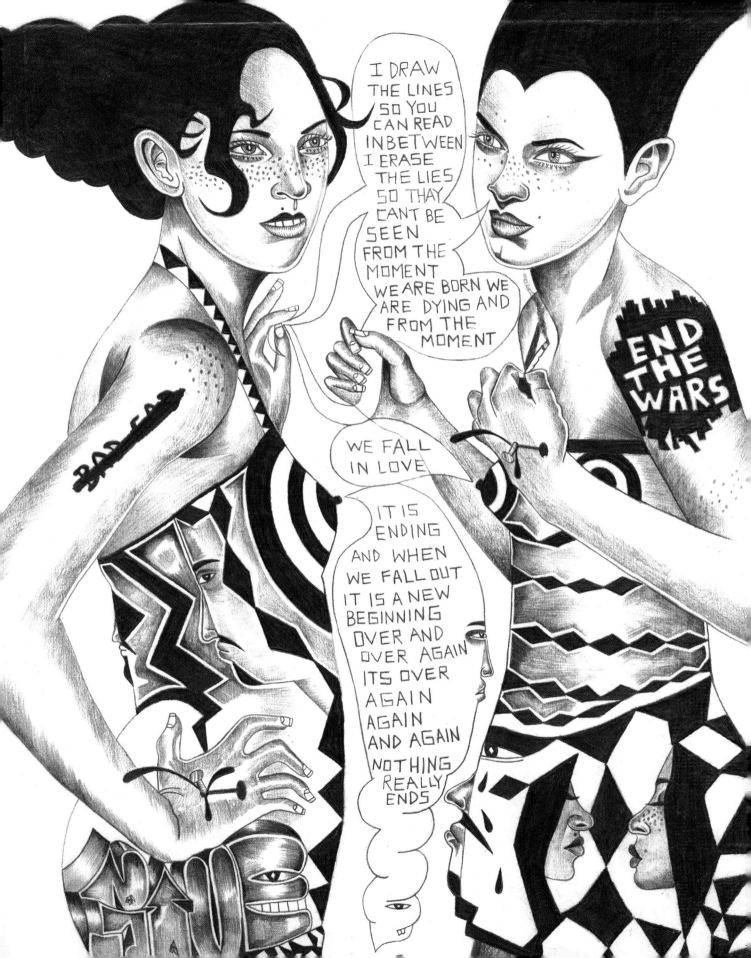

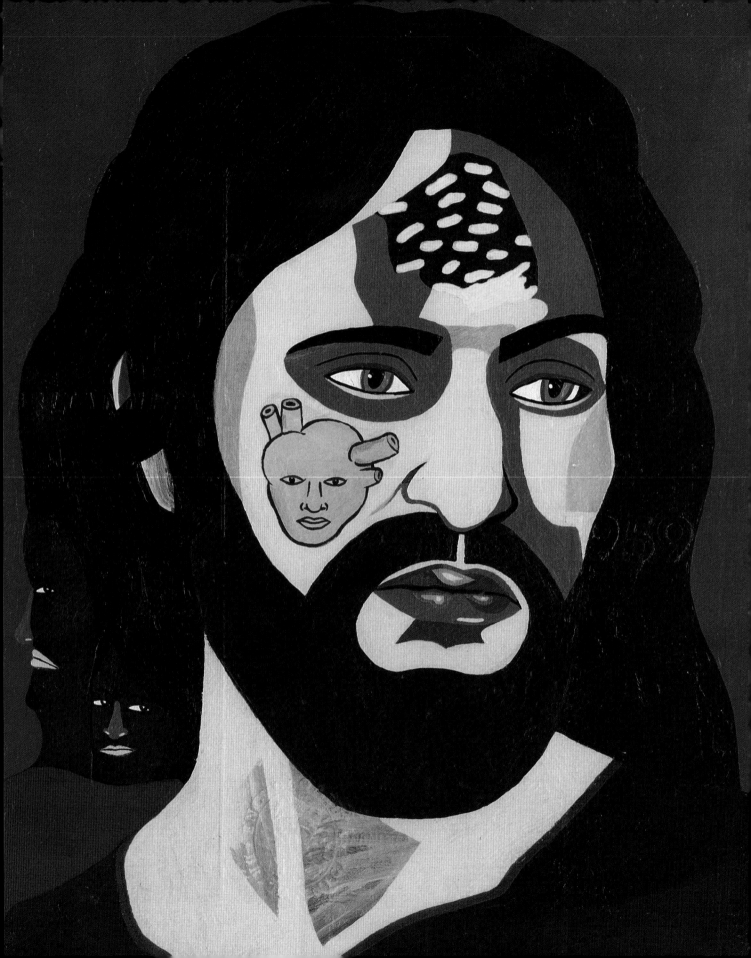

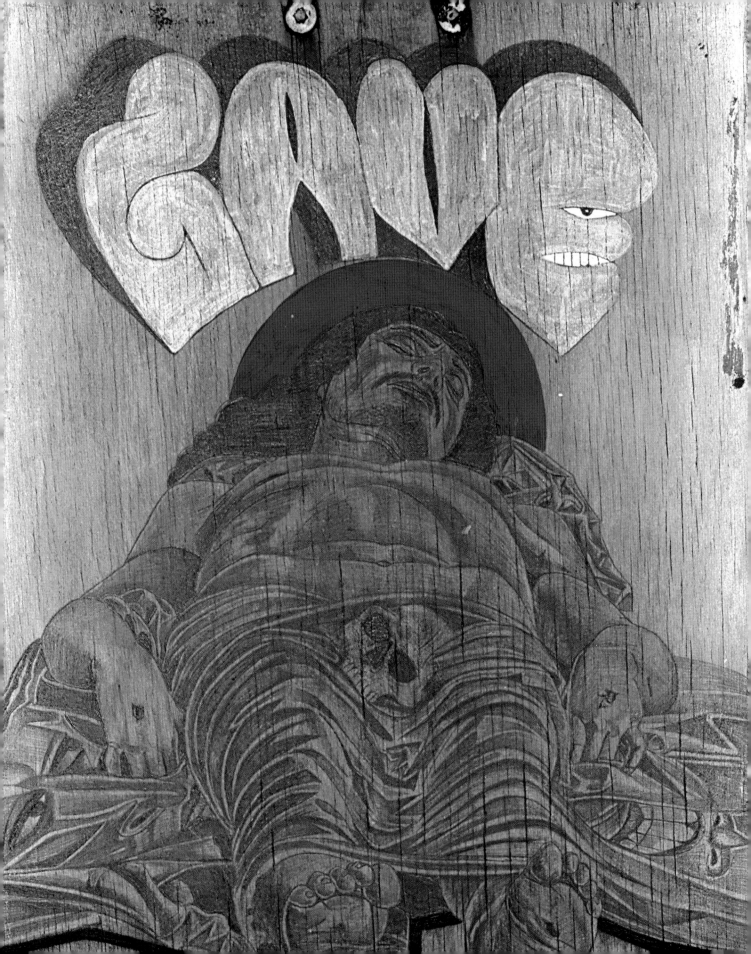

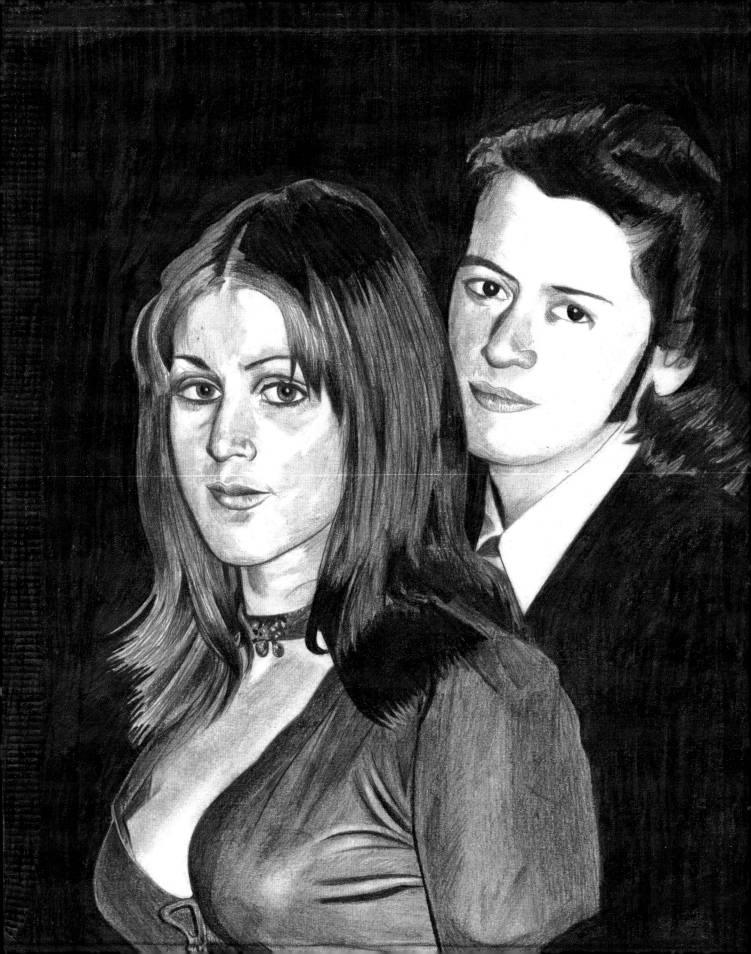

EVERYTHING THATS HAPPENING
MOST ASSUMPTIONS DONT EXPECT
IN A FAR CORNER
THAY DONT HAVE TIME TO WORRY

ABOUT
THE RULES
EYE CONTACT TURNS HER ON
HER CONTACT TURNS HIM ON
WAR TURNS THEM OFF
NAKED AND DEAD
ITS HARD TO GET OFF!

BEST
H
EXPECT

DANIEL JOHNSTON

The award-winning documentary "The Devil and Daniel Johnston", a property of Sony Pictures Classics, opened to rave reviews on March 31st 2006, in both NY and LA. Running concurrently with the opening of the film was a body of Daniel's work at the Whitney Museum's Biennial exhibit!

Much has also been written about the music of Daniel Johnston. And there is good reason; Daniel is one of the greatest songwriters of this or any other generation. Daniel's been playing his intensely unique songs since he was a young teenager and garnering fans all over the world, including such notables as Kurt Cobain, David Bowie, Pete Townshend, Matt Groening (creator of "The Simpsons"), Jad Fair, Lou Reed and Maureen Tucker. Unfortunately, much less has been written about his artwork. That, however, is beginning to change. Over the last few years, Daniel's drawings are showing in larger and larger galleries and prices for his work are climbing steadily higher. What is astounding about Daniel's work is the fact that he is an absolute unending wellspring of creativity, the likes of which I have never witnessed before. No creative blocks here… what he thinks and feels gushes out on to the paper, or into a song. But, perhaps the most incredible part of the story is that all of the superlatives that have been used in describing how wonderful his music is can also be used for his artwork.

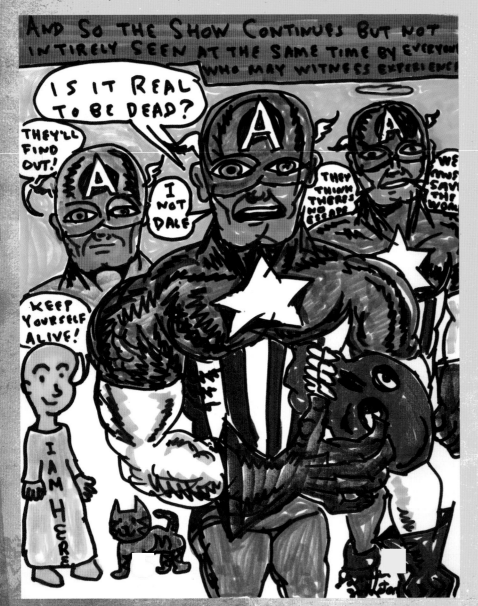

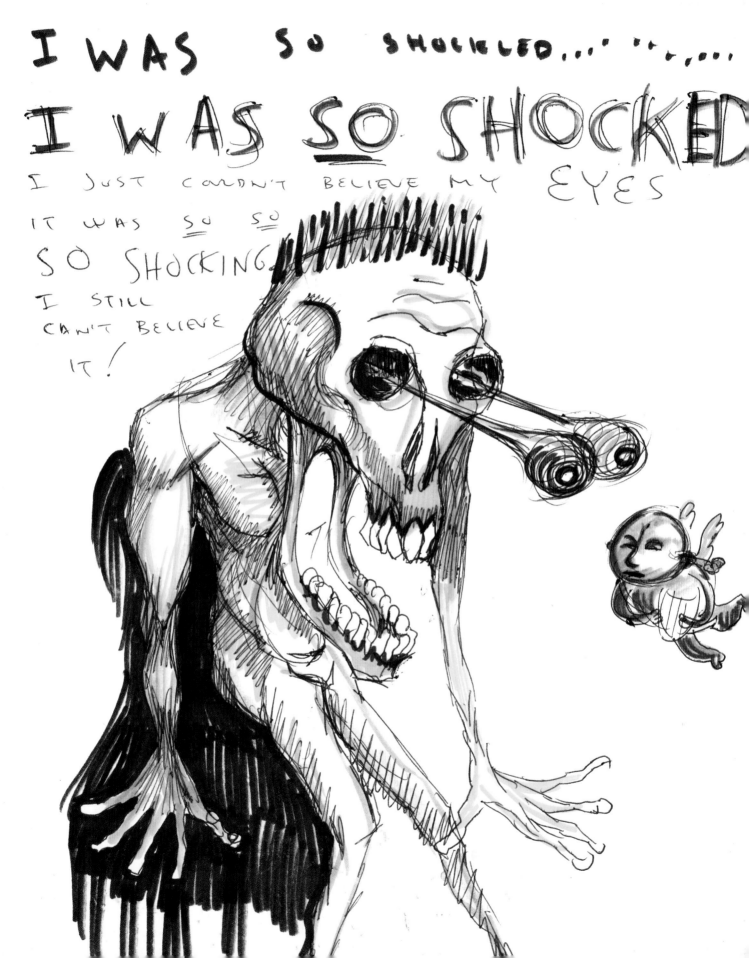

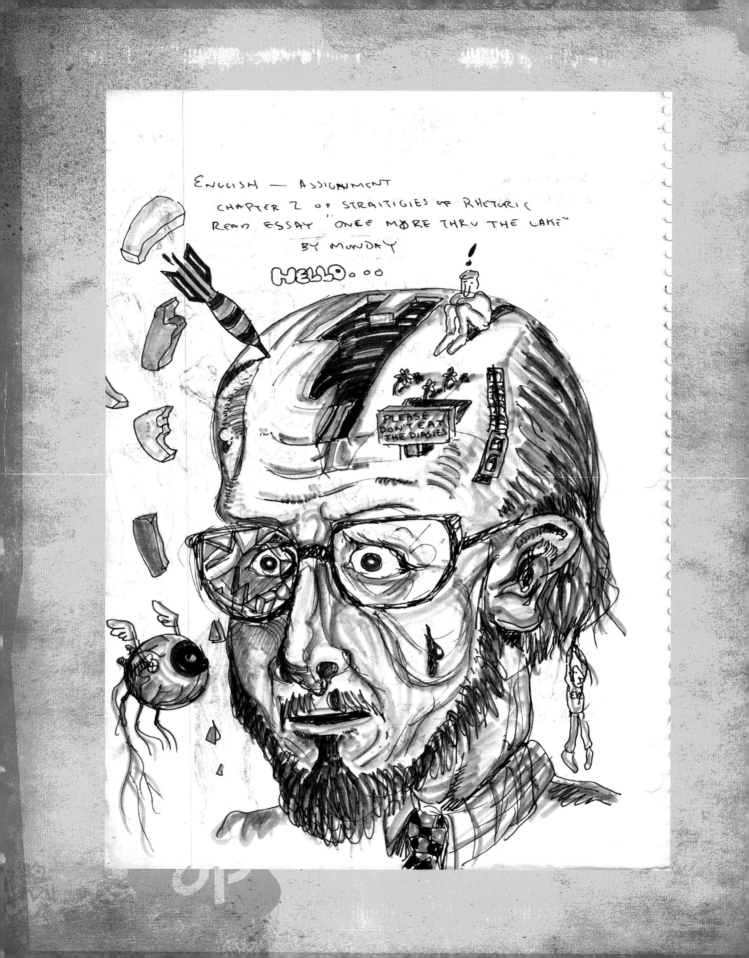

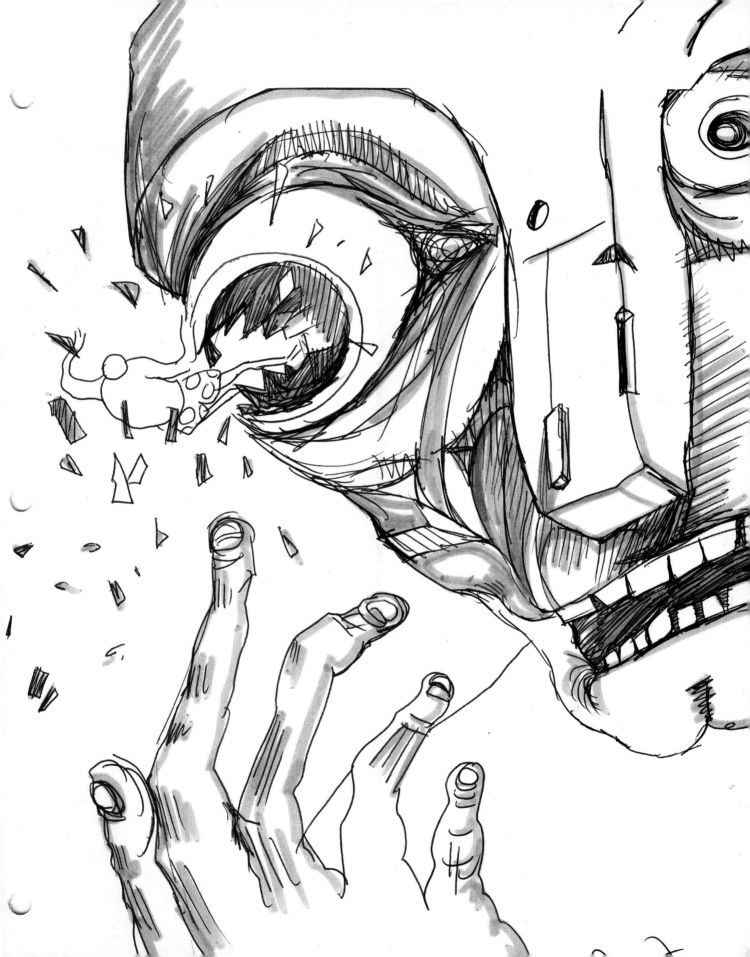

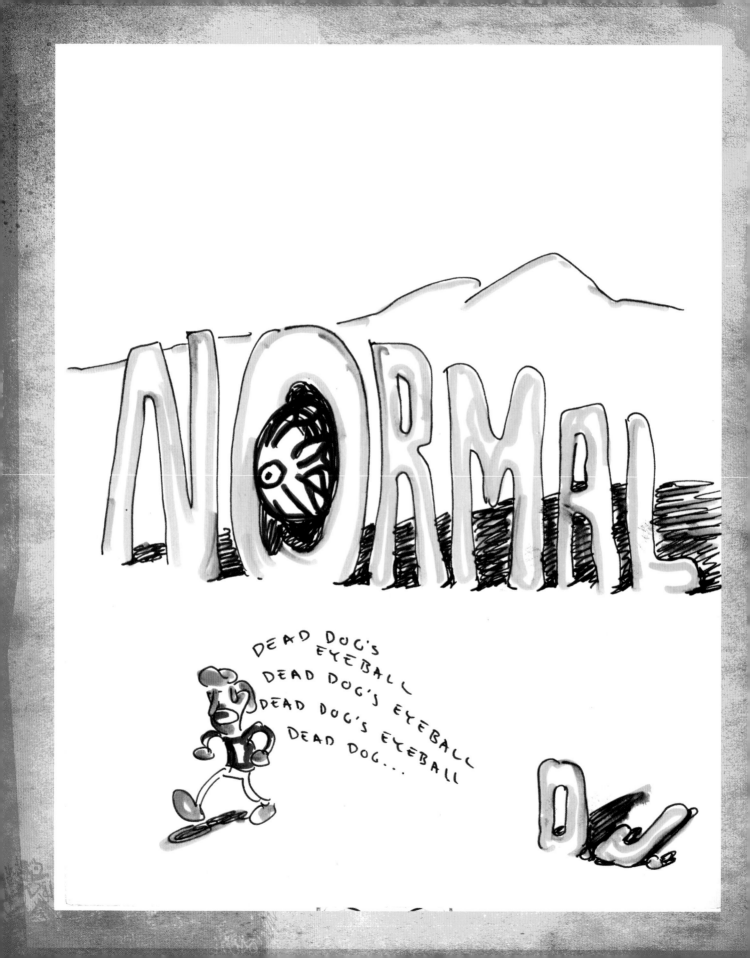

Circumstances

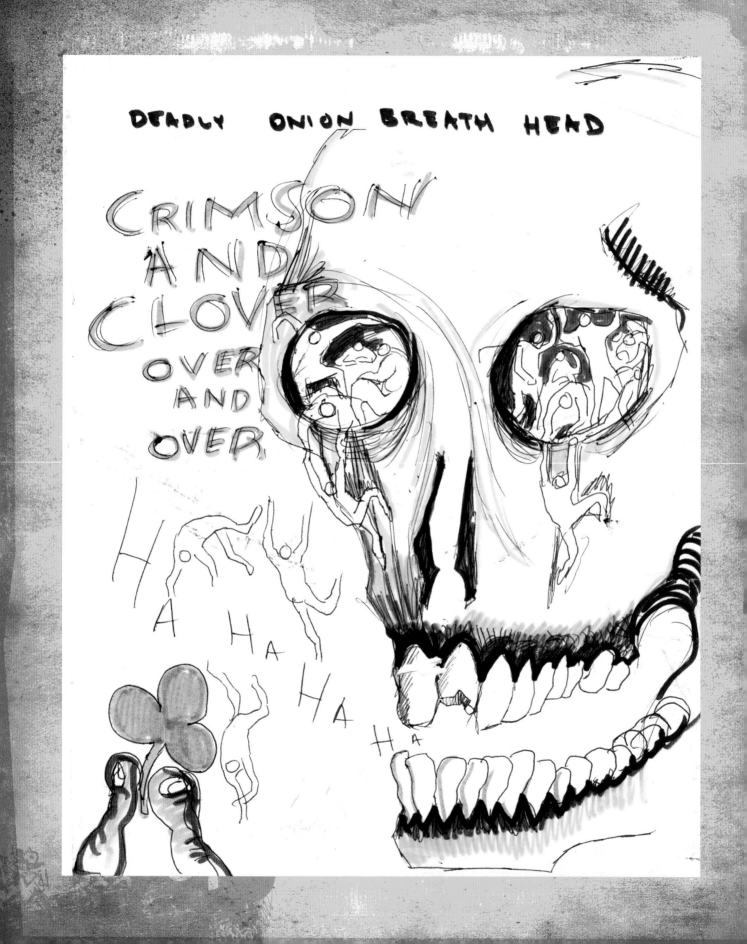

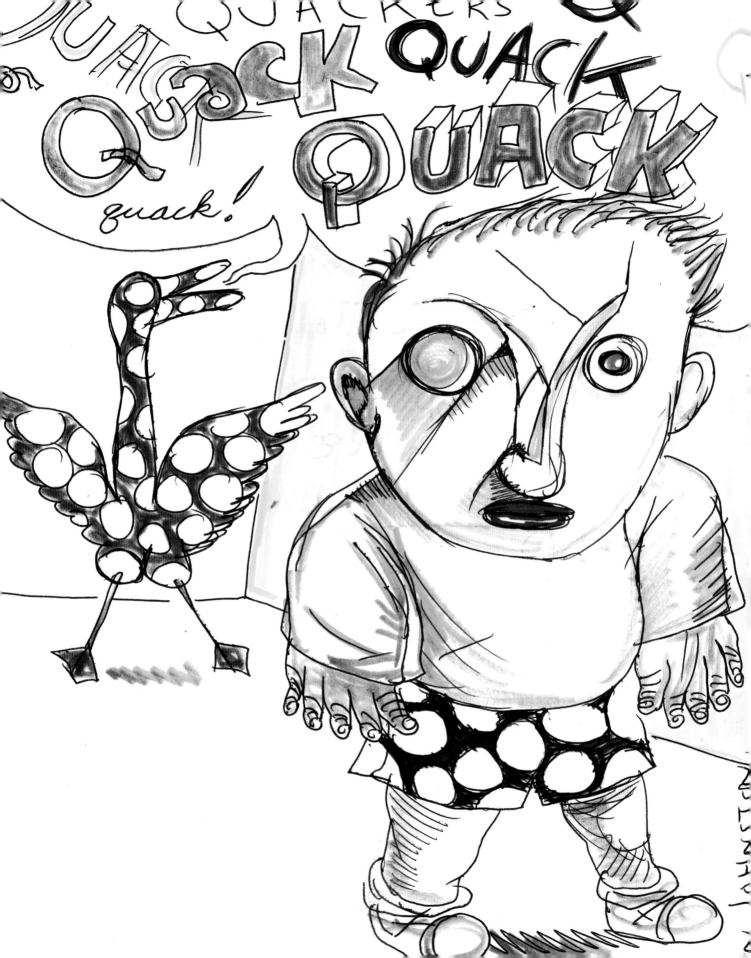

PAPERMONSTER

SHOW DATES
SEPT 14 - OCT 17

PaperMonster is a stencil graffiti artist who's vivid and intricate pieces explore the beauty behind the eyes and subtle facial expressions of women. Born in Puerto Rico, PaperMonster incorporates stencil and pasting techniques to create unique pieces of art. His work can be found on many surfaces as he combines pop culture icons, Asian typography, patterns and texture to present vibrant emotions and stories. PaperMonster's stencil art pieces allow the audience to take his creations at pure face value or explore deeper into each piece.

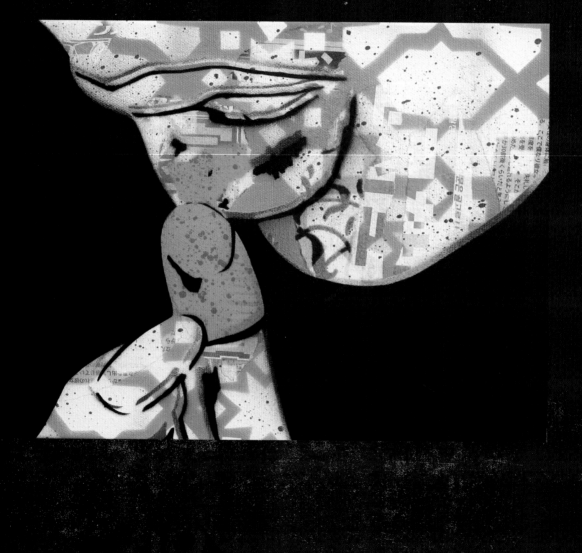

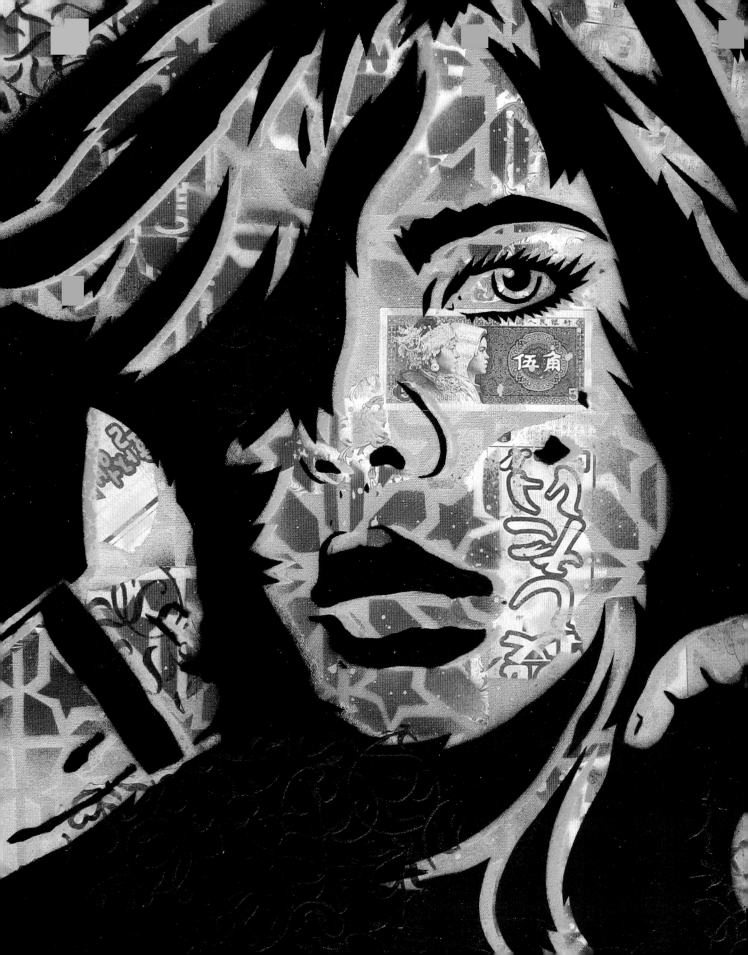

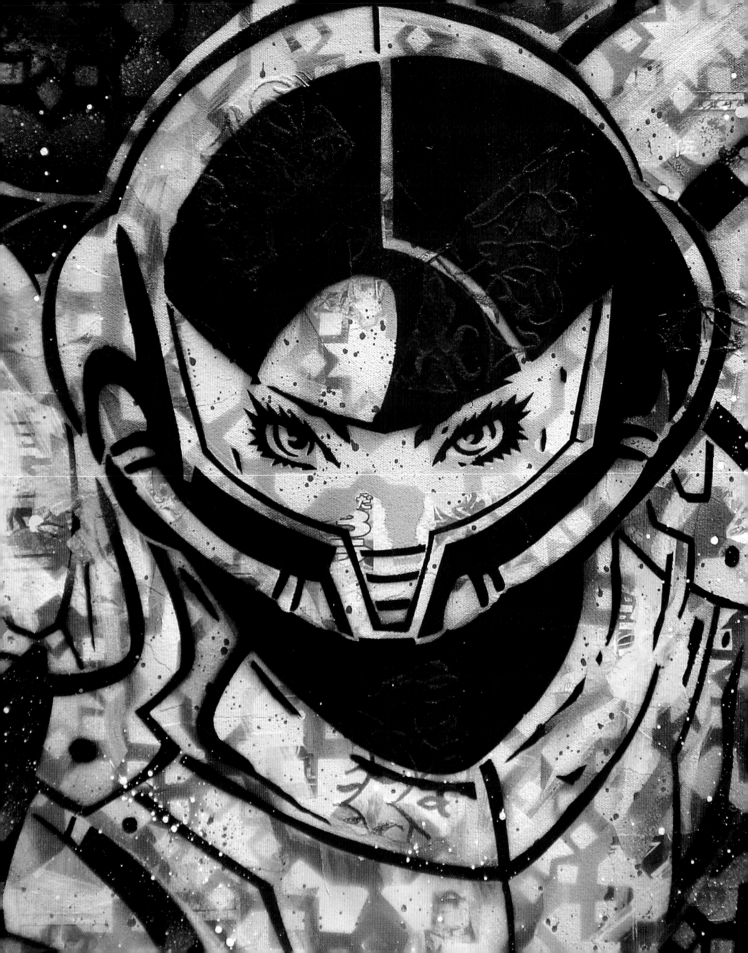

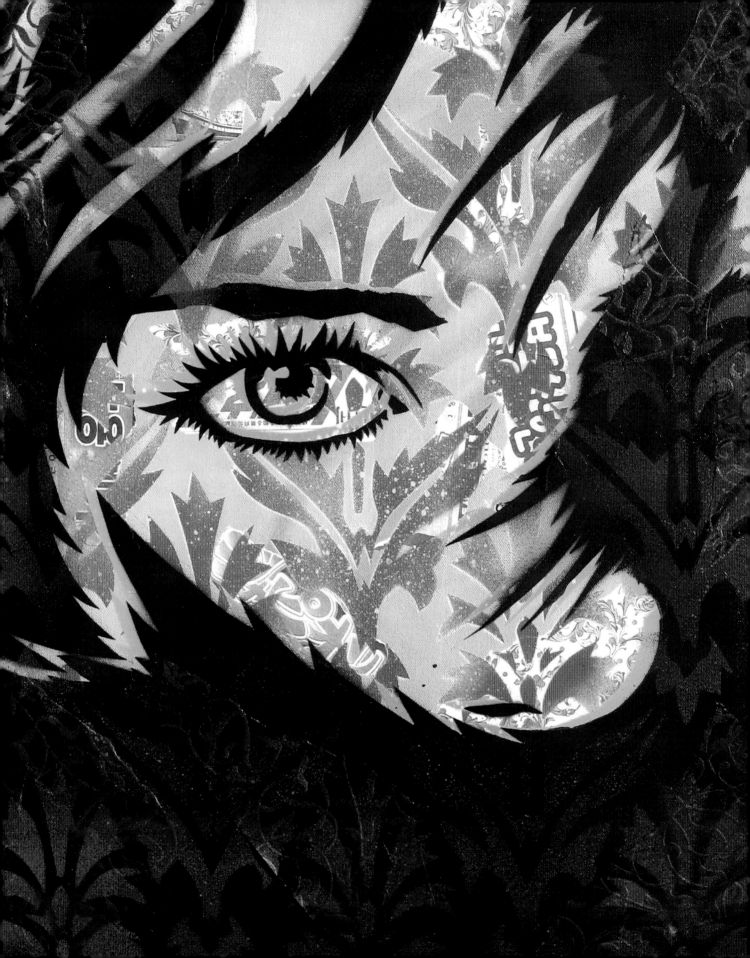

STEPHEN TOMPKINS

SHOW DATES
AUG 7 – SEP 7

Stephen Tompkins' work has appeared in many exhibitions throughout the US and in Europe beginning in the mid 1990s, with a collaboration exhibition with Daniel Johnston. His work includes painting, drawing, sculpture, soundworks, and stream-of-consciousness animations, some consisting of hundreds of drawings each. His idiosyncratic style, that cuts across numerous mediums, reveals a methodical scrambling of a personal cartoon memoir and comic archaeology. His early interest in art was spawned by his studies in philosophy and existential psychology. He has a BA in Philosophy and a "near-Masters" degree in Philosophy with a background in Phenomenology and Semiotics.

Brad Martin, contributing writer to Juxtapoz recently wrote that Stephen's work is "like a Merry Melodies hit and run or some boiling hell for all the forgotten toons."

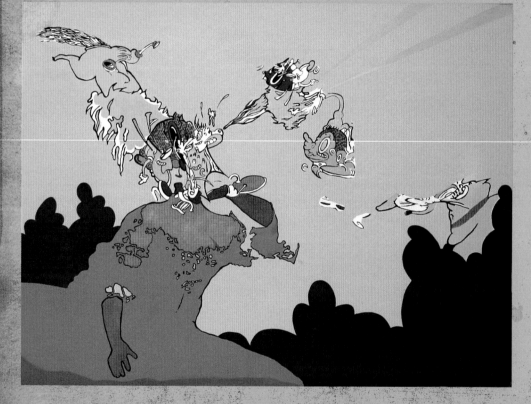

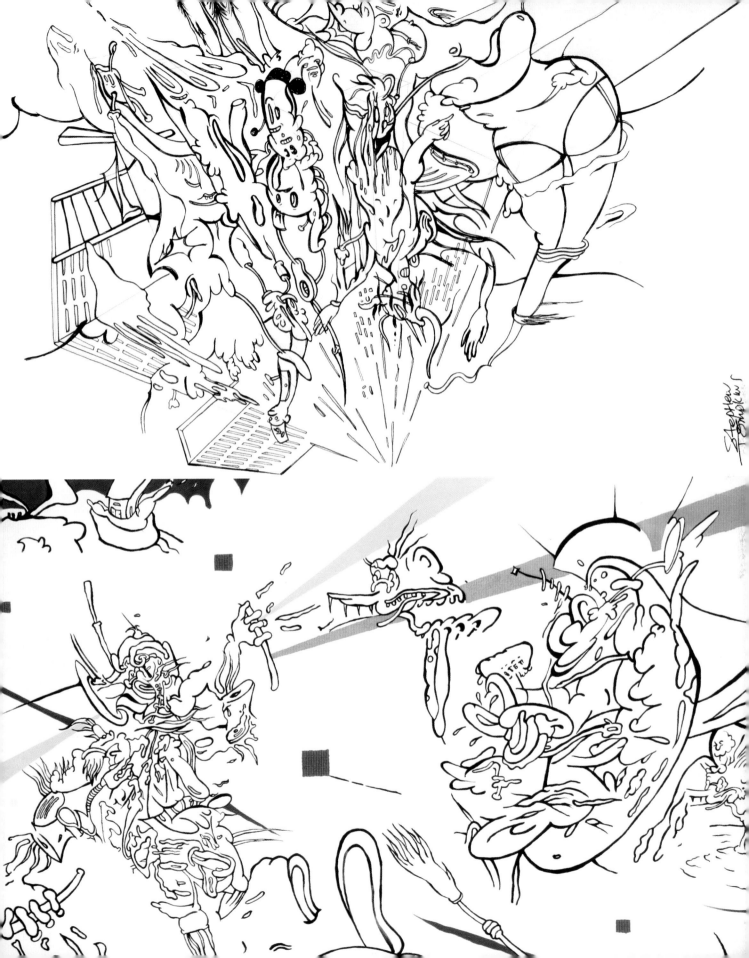

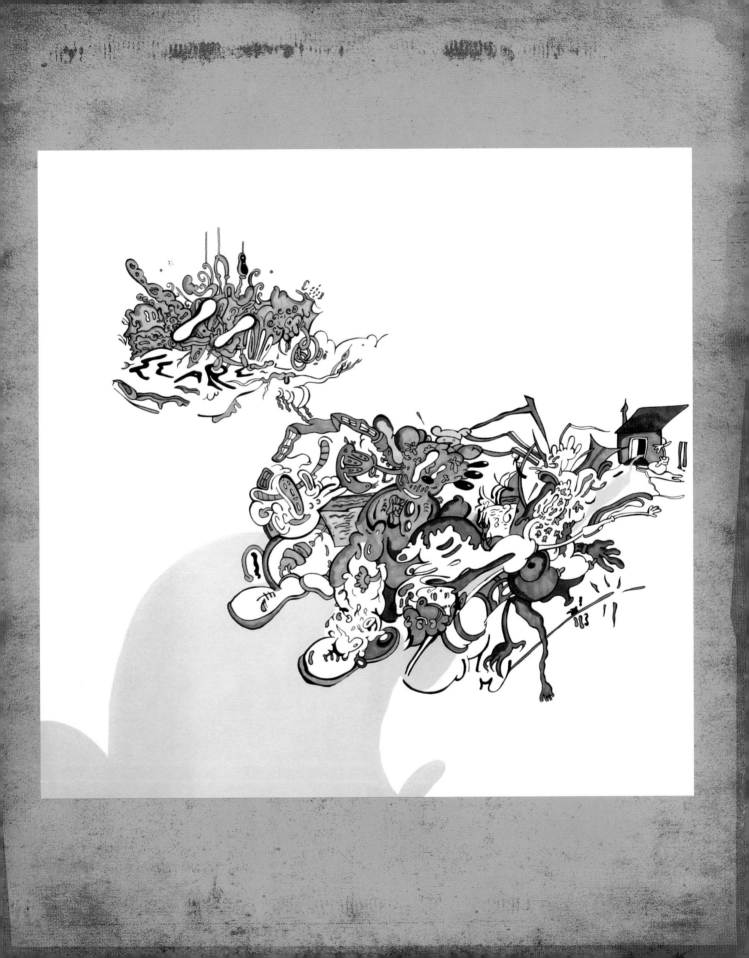

KIME BUZZELLI

SHOW DATES
OCT 15 – NOV 21

Kime Buzzelli found early inspiration in her collection of "paper dolls," constantly creating costumes and dramas for them. When she began painting, this "narrative" of fashion informed her work, painting women with a dialogue designed from an addiction to clothing. This is the basis of Buzzelli's work today. Known for her paintings of wayward nymphs, broken-hearted waifs and androgynous party girls, Kime explores the pain, joy, and integration of fashion in the feminine psyche. After studying fashion illustration at Parson's School of Design in New York, Buzzelli earned two degrees in painting and art education from Ohio State University.

Since then, Kime has been exhibiting her work throughout the world in such esteemed galleries worldwide.

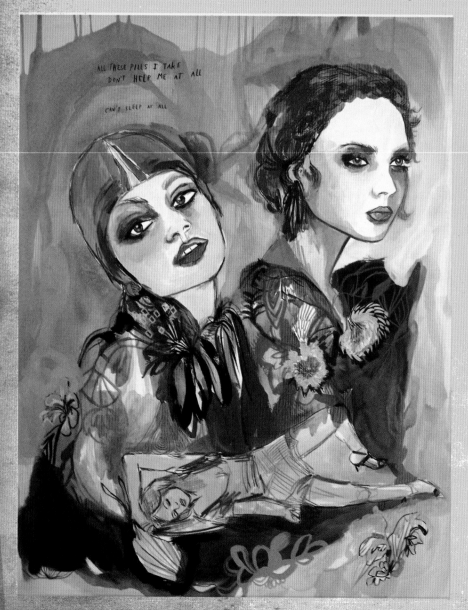

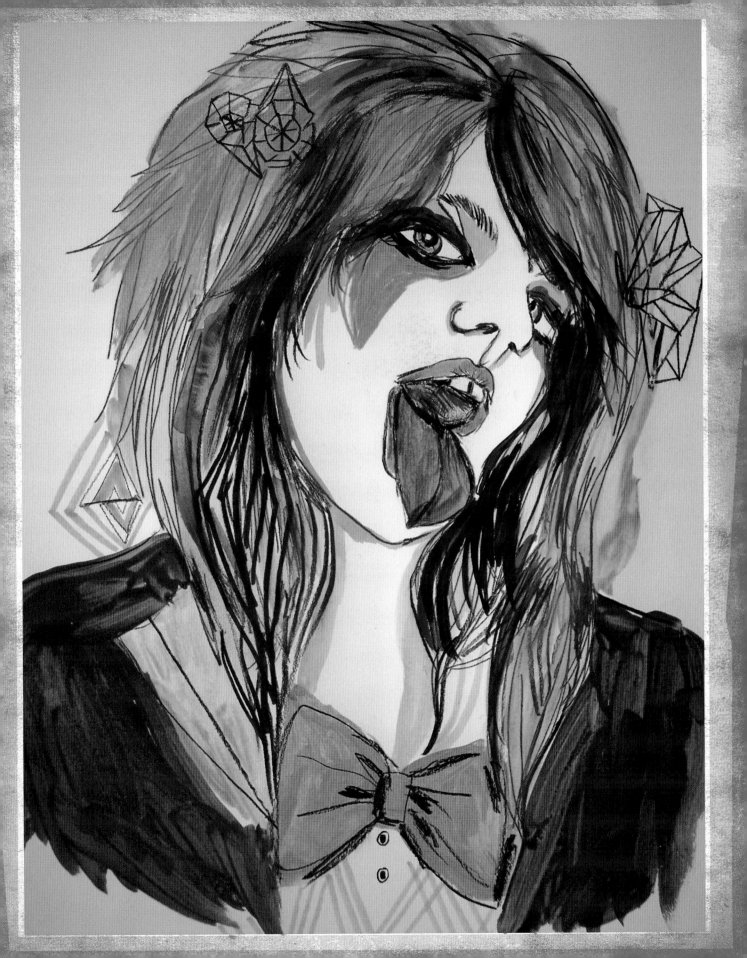

WHAT are YOU GONNA do, WHEN YOU CAN'T have everything?

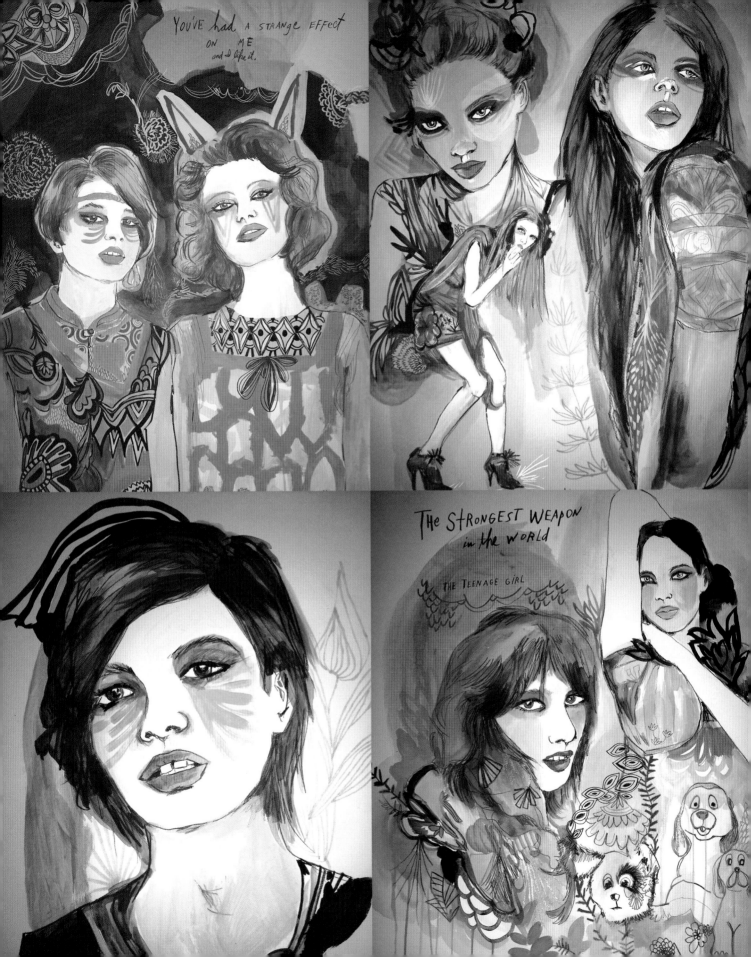

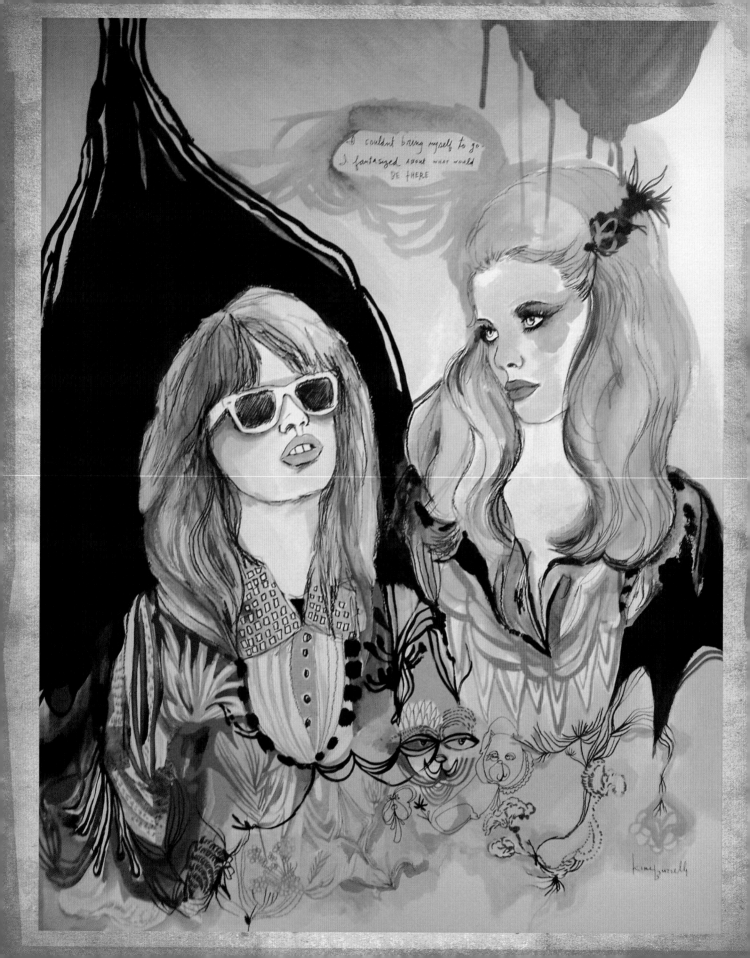

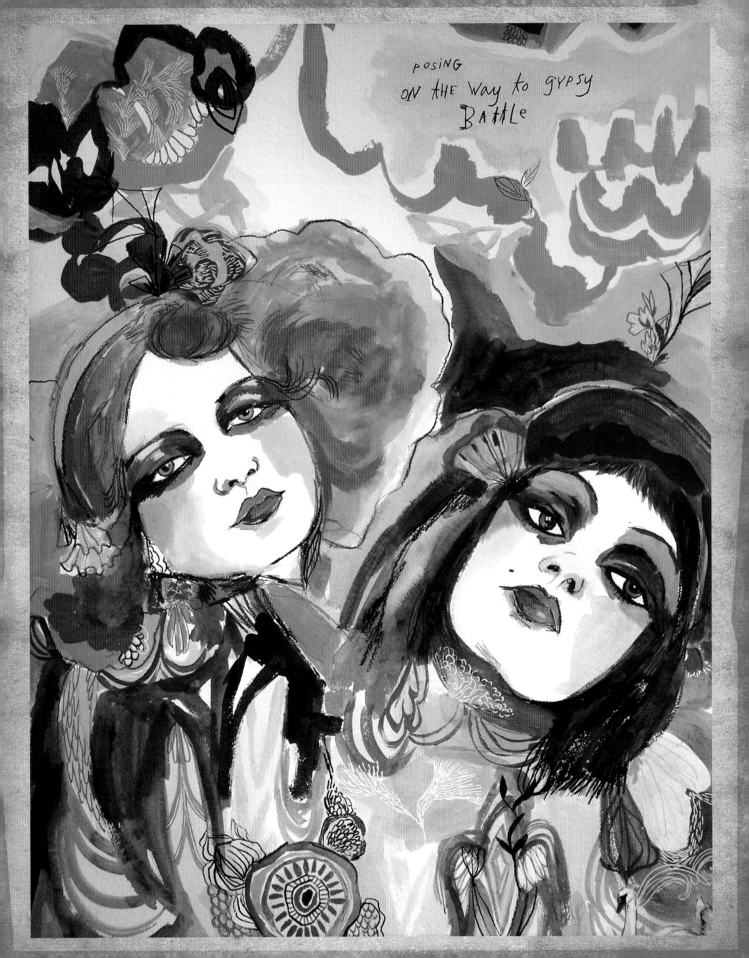

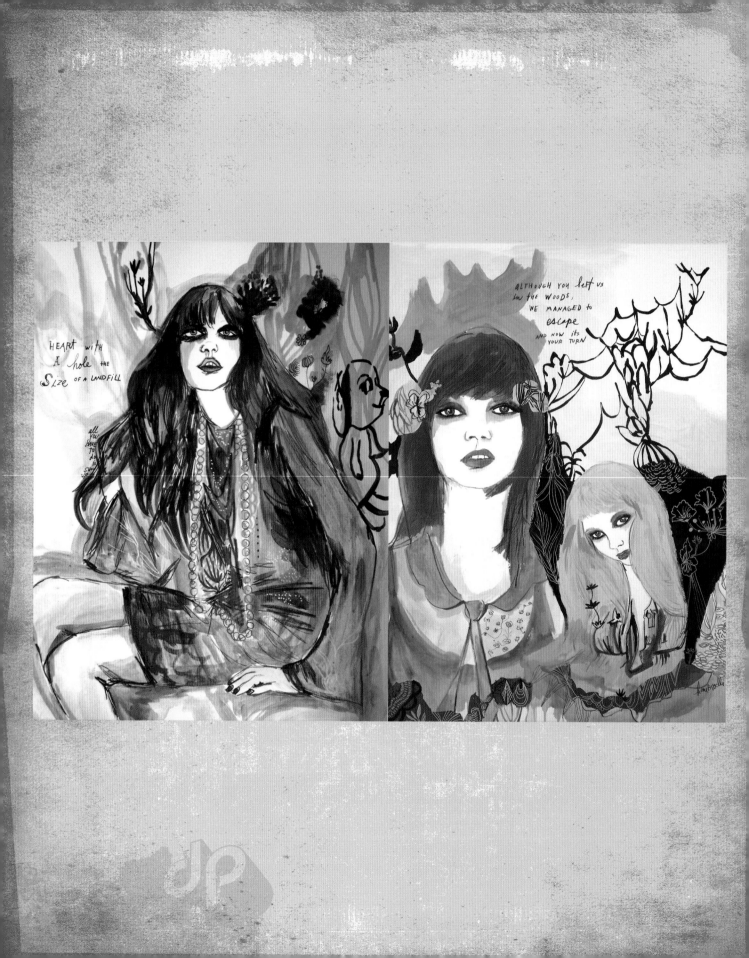

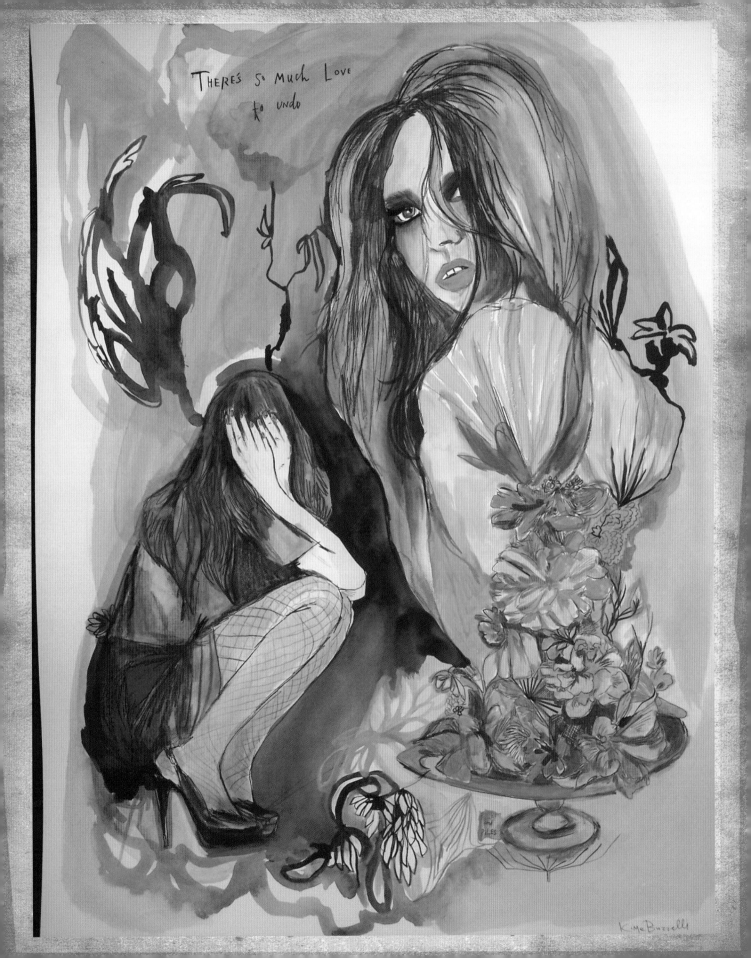

DENNIS MCNETT

"I was attracted to making prints for several reasons. A big one was the graphic quality of woodcuts mimicked all the images I was drawn to as a kid. They had the same contrasty harshness as punk album covers and skate graphics. Another reason would be that the medium is primarily drawing with a chisel and the combination of drawing with a resistance against the surface your carving, the unique mark it makes, and the physical carving of the image gives it a certain energy. The medium makes sense and feels right for what I'm doing. The final reason would be the ability to make multiples of my work which makes them less of a precious work like a painting and allows me to make it more accessible to people I want to have it."

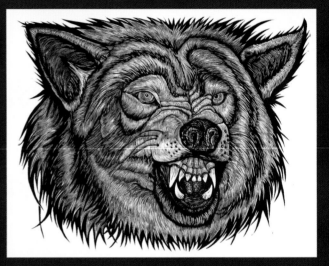

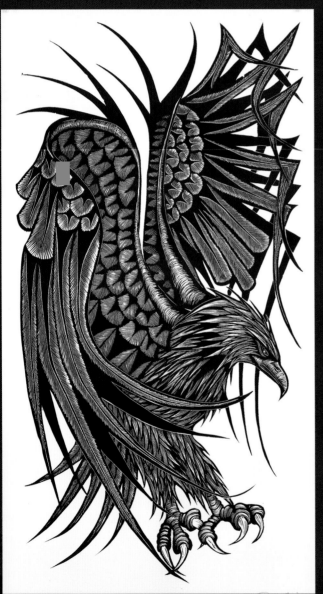

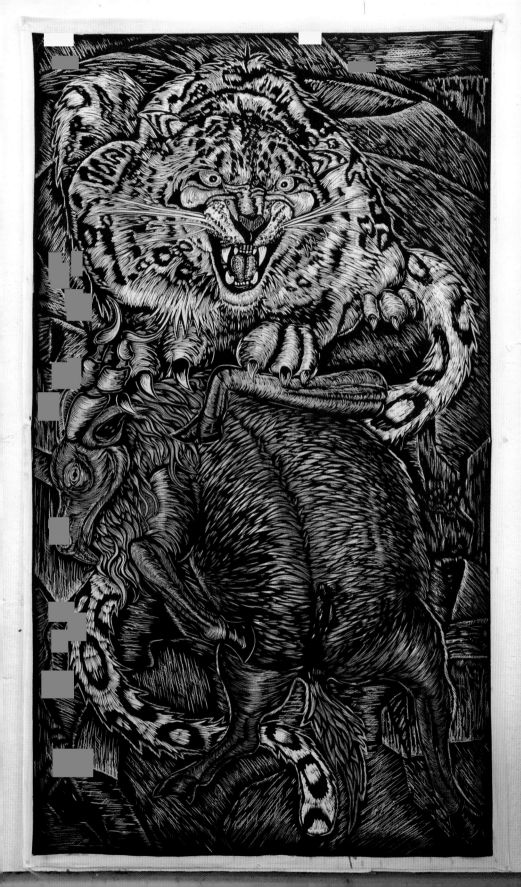

GHOST

One of New Yorks most celebrated Graffiti artists showcased at Dirtypilot.com Ghost is one of the most intriguing and respect-
ed New York City Graffiti artists who has taken the successful leap into the fine art world and creating the buzz at Dirtypilot.
com. A NYC subway era legend, Ghost developed his unique formal technique through his involvement with the NYC Graffiti
movement where he became recognized for his original style and vibrant color combinations, along with his sense of satire.

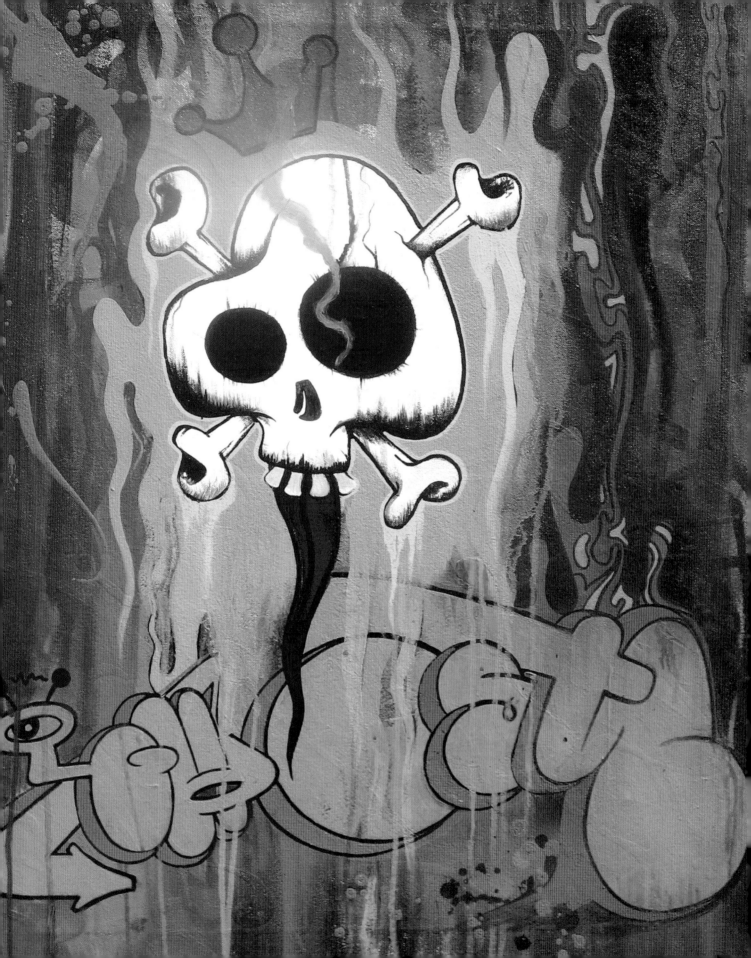

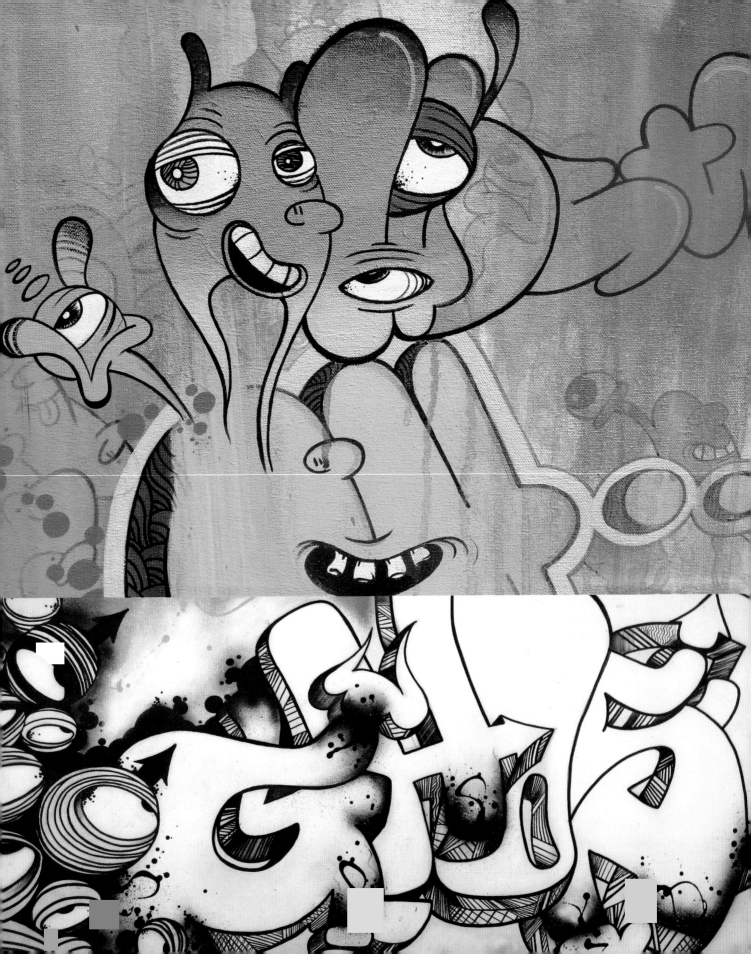

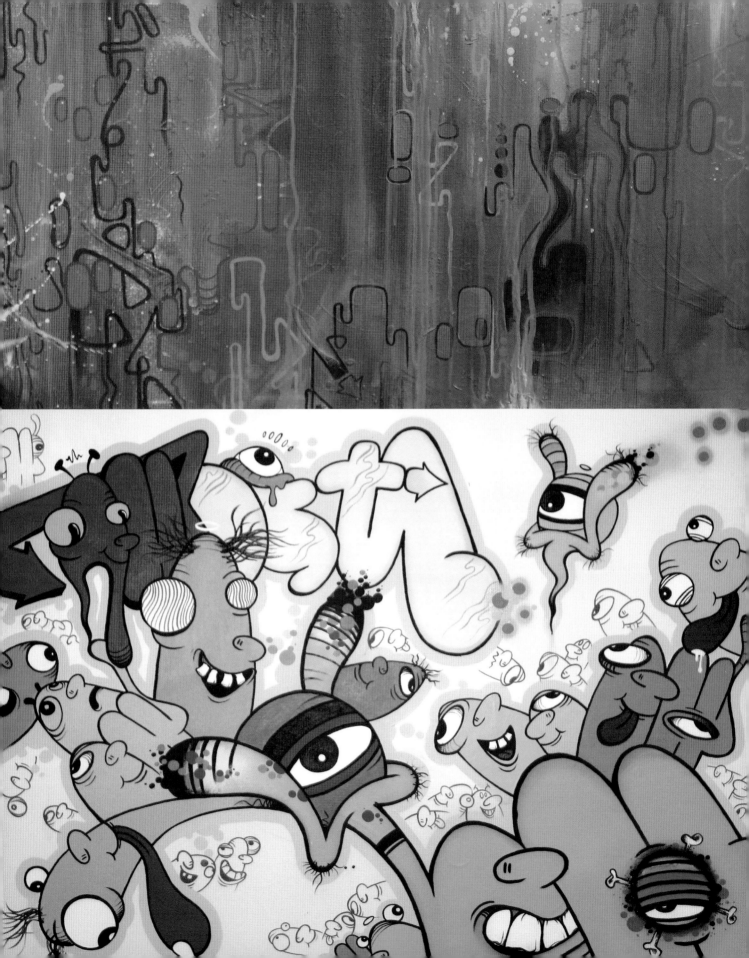

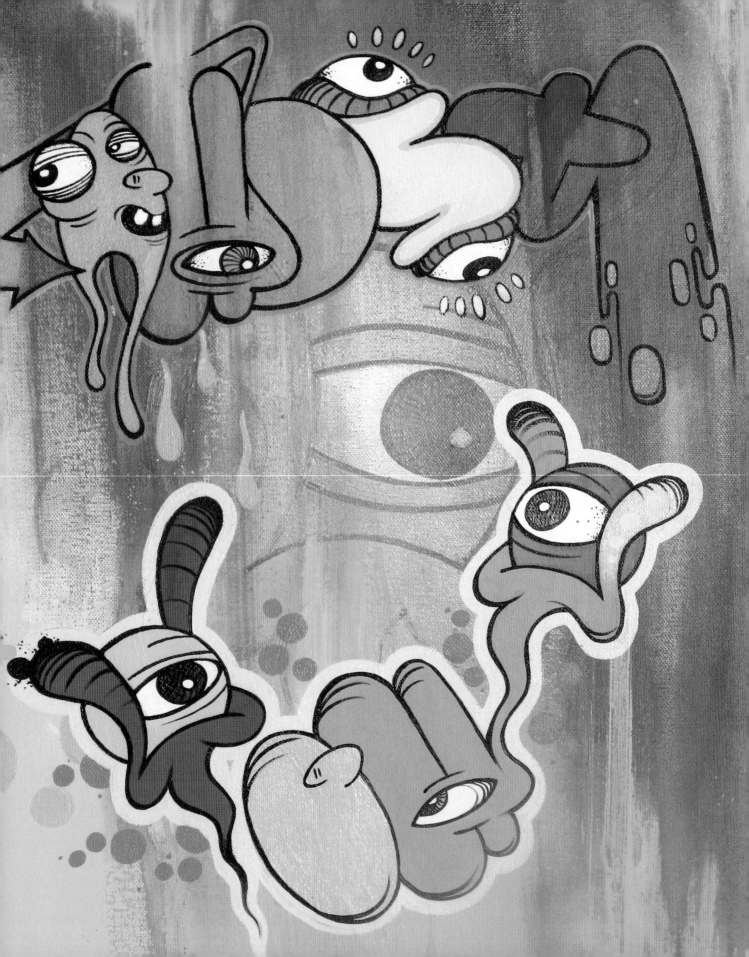

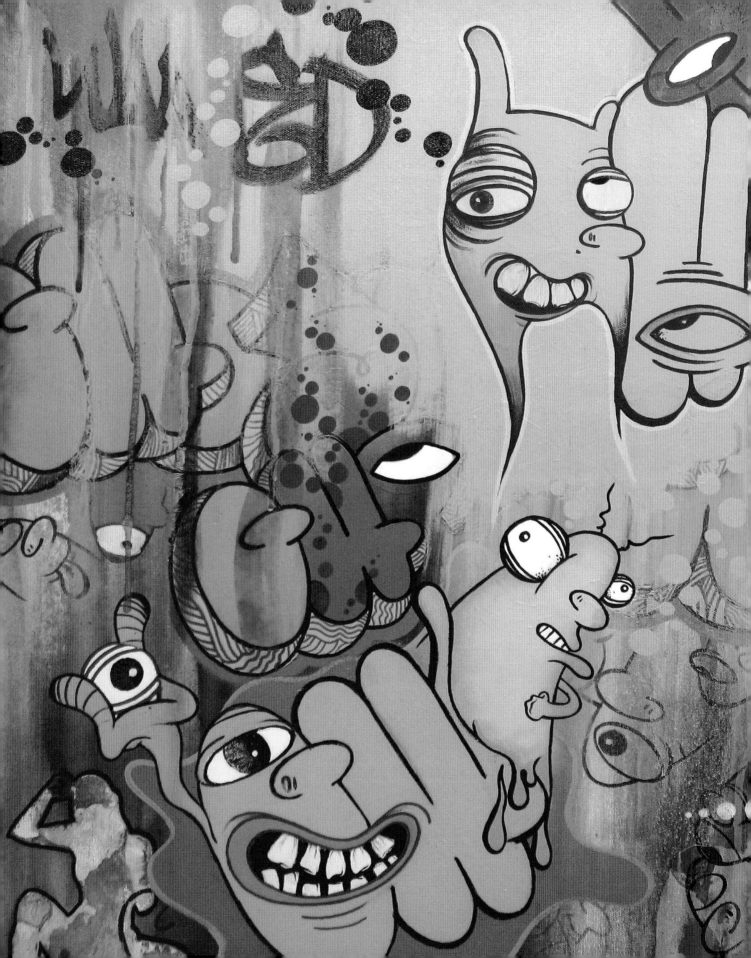

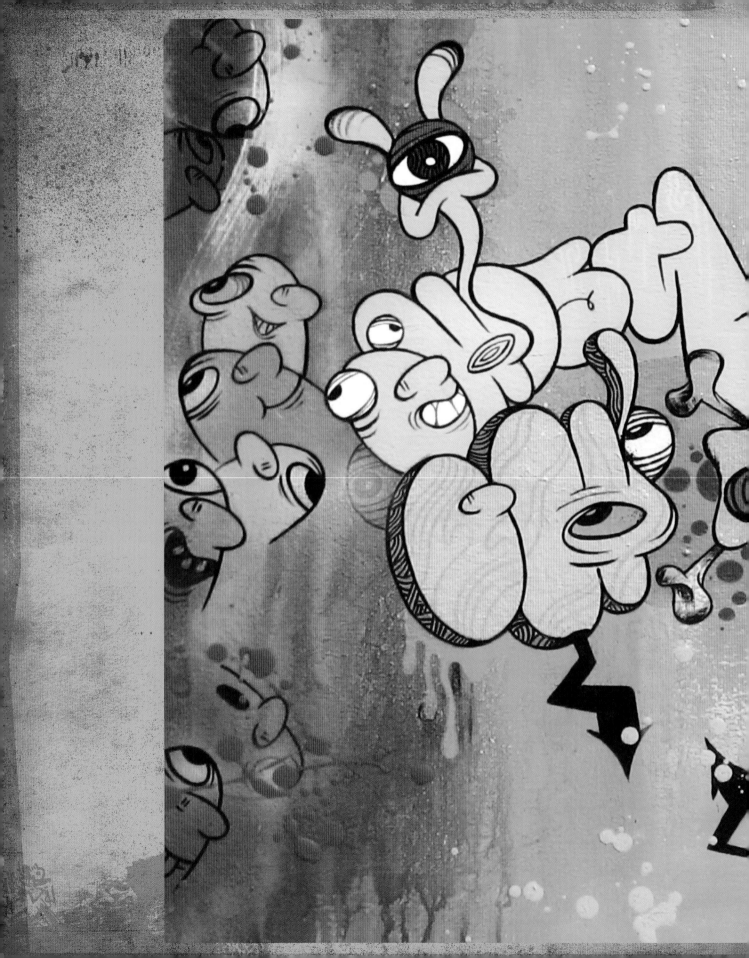

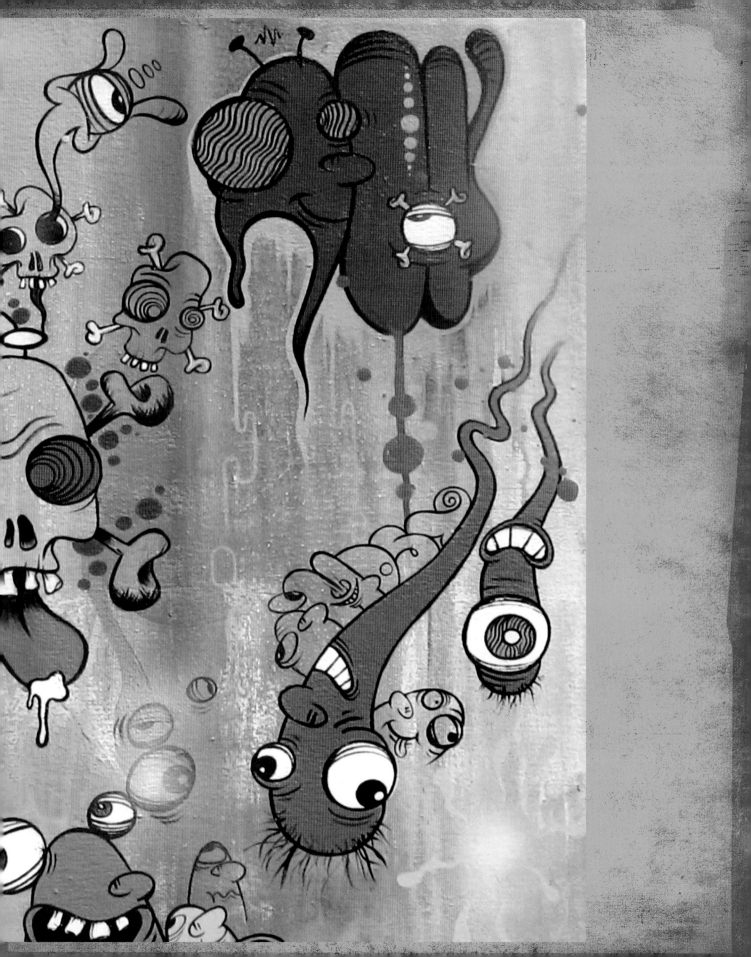

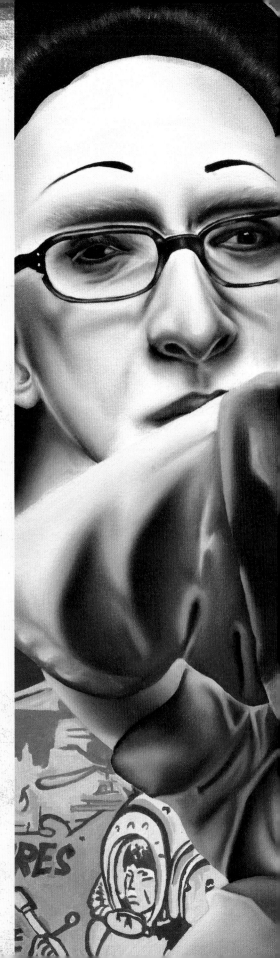

BRAVO JETT

SHOW DATES
JULY 23–AUG 23

Following in the tradition of 60's pop artists, Bravo Jett has burst on the scene, juxtaposing advertising images from popular culture in his paintings. Using his meticulous blending technique often confused with airbrush, Jett puts his original stamp on the TV, brand images, and media messages that bombard our senses daily. His works both excite and entertain, while giving us a gripping landscape of character and color to capture and deliver their meaning.

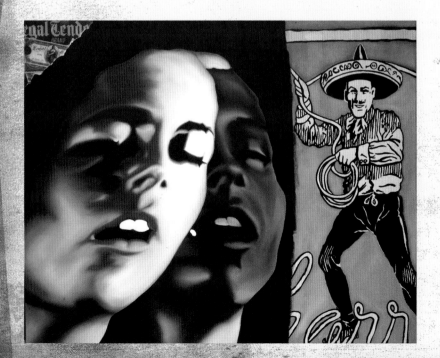

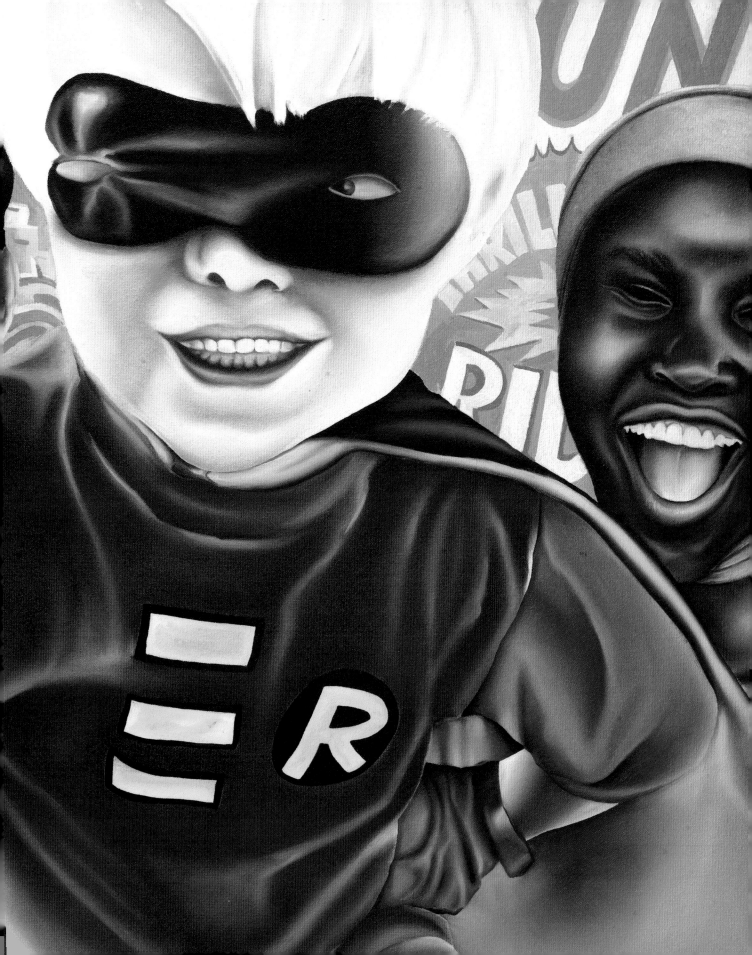

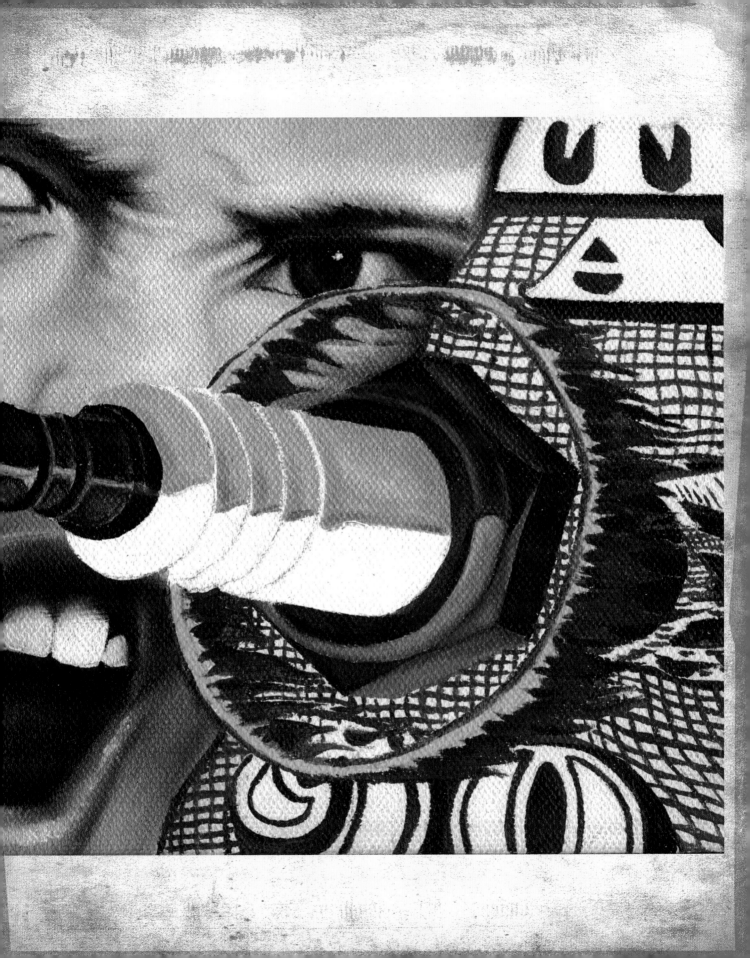

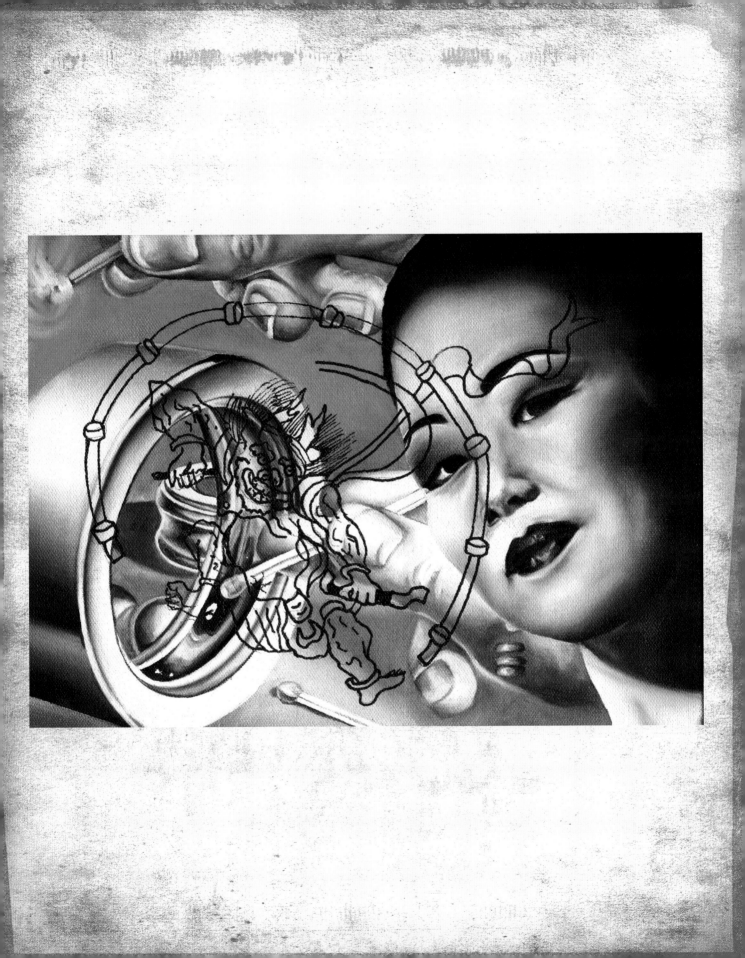

JUSTIN BUA

SHOW DATES
FEB 16- MARCH 22

These drawings represent the many complex, multifaceted, urban characters that I grew up around during my youth in New York City. Living on a typical cramped Manhattan block, I shared close quarters with a colorful cast of ethnically ambiguous and even sexually ambiguous characters. They were street gurus– proud, confident, and wise, always spouting a range of sermons, truths, and bits of wisdom about life. Whether they were hustling themselves, talking someone out of a fight, or pep-talking a fellow soul, they were always positive. We all knew they lived hard lives and were always struggling, but their positivity and outlook kept everyone around them inspired. As a tribute, I drew them lost in a zen moments, escaping the realities of the urban jungle we lived in.

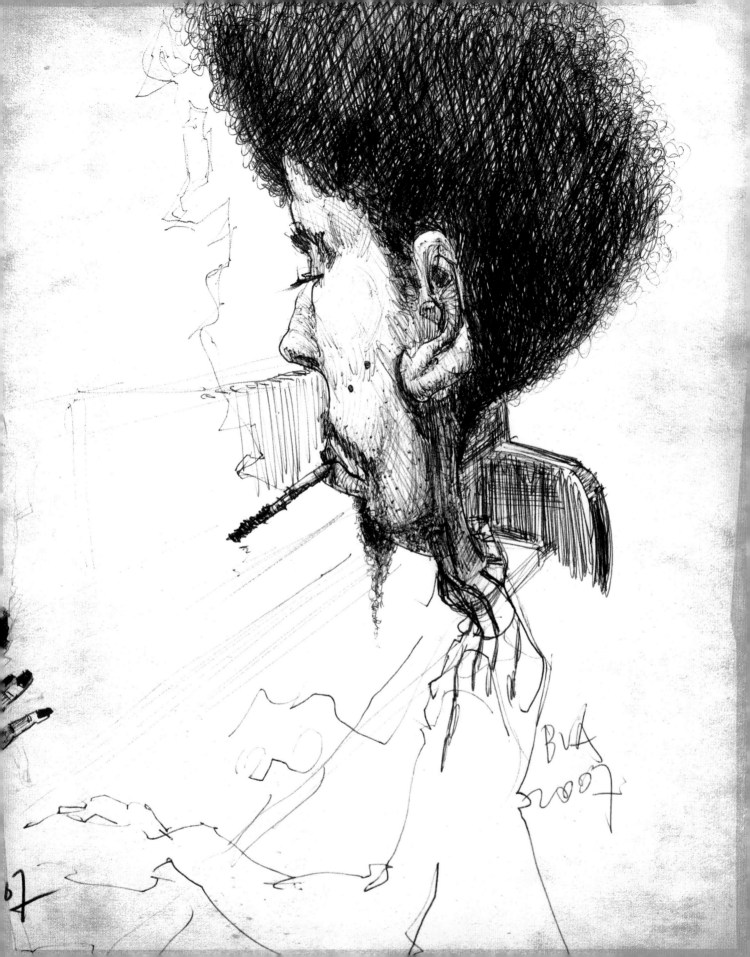

BVA
2007

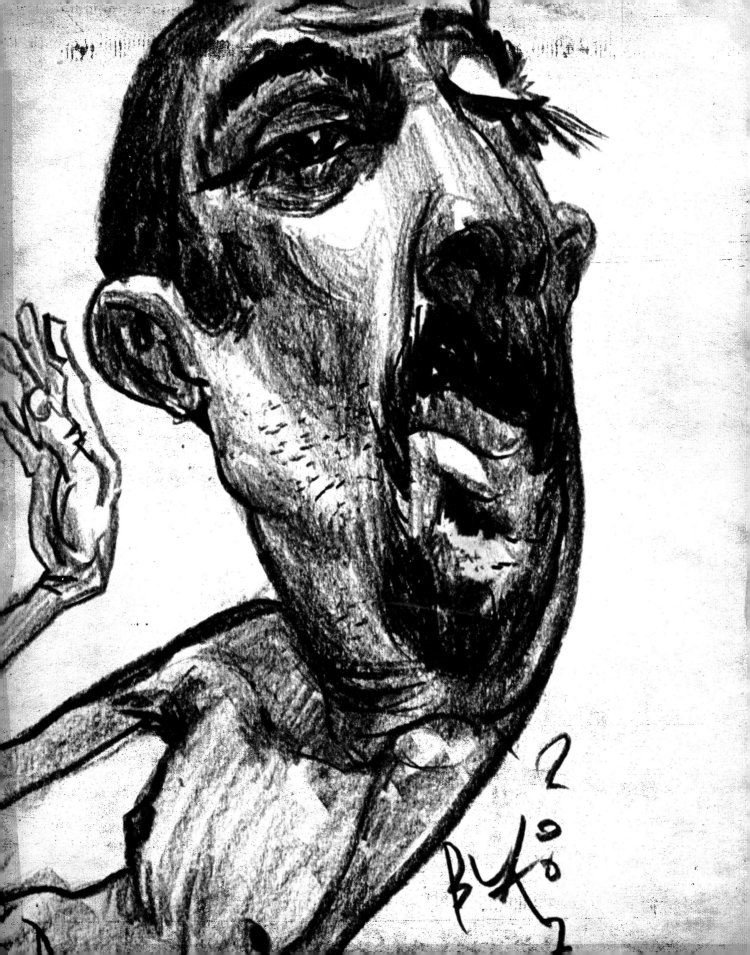

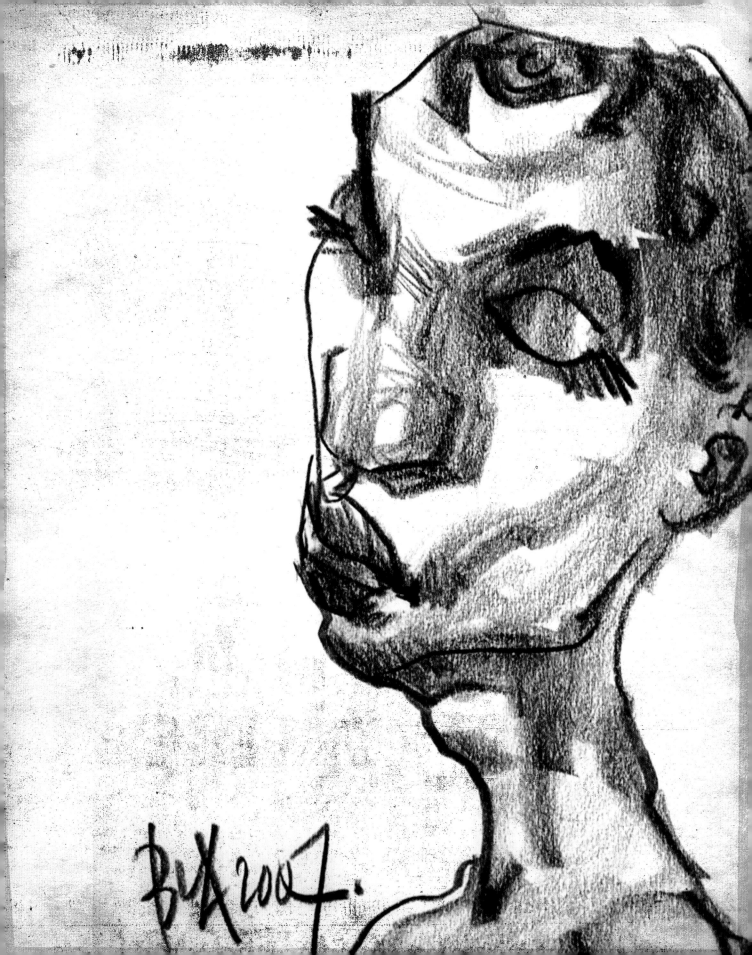

MICHAEL KRUEGER

SHOW DATES
JAN 15 - FEB 15

Michael Krueger is a father, an artist and a teacher. He was born on January 5, 1967 in Kenosha Wisconsin. His family moved to South Dakota in 1970 and he spent his childhood years in Sioux Falls. These formative years in the West cultivated a fondness and curiosity for the history of Westward Expansion and the epic struggles that were cast on the Great Plains. In 1990 Michael earned a BFA from the University of South Dakota and in 1993 he graduated with an MFA from the University of Notre Dame. In 1995, Michael moved to Lawrence for a teaching post at the University of Kansas. Michael's creative research has taken him all over the globe from Asuncion, Paraguay to the United Arab Emeritus, to Scotland, England, Belgium, France and Italy.

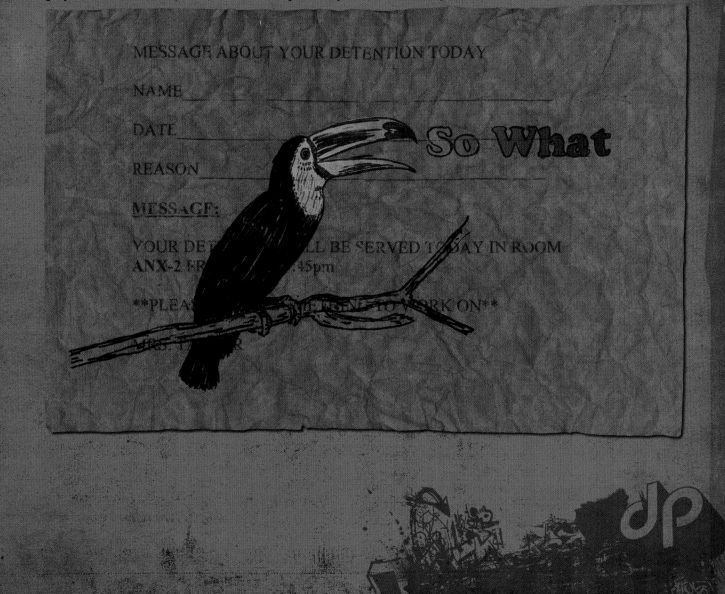

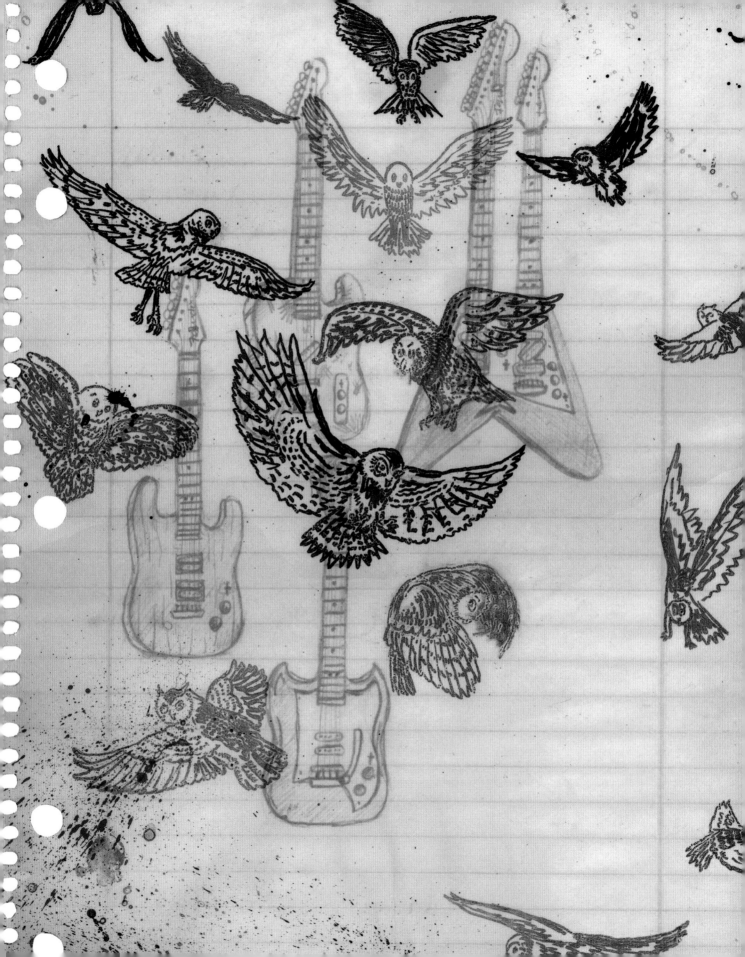

RAVEN

LED ZEPPELIN
ZoSo

BLACK SABBATH

Expansion
1920 - 1948
RCA-NBC
CB KROY

Downfall
1948 - TV - 1955 Advertisers
Network - Public Radio - Independent
Audience

GREG GOSSEL

SHOW DATES
AUG 7 - SEP 7

Greg Gossel was born in 1982 in western Wisconsin. With a background in design, his work is an expressive interplay of many diverse words, images, and gestures. Gossel's multi-layered work illustrates a visual history of change and process throughout each piece. His work has been exhibited throughout the U.S. and abroad, including San Francisco, New York, Los Angeles, and London. He currently resides in Minneapolis, Minnesota.

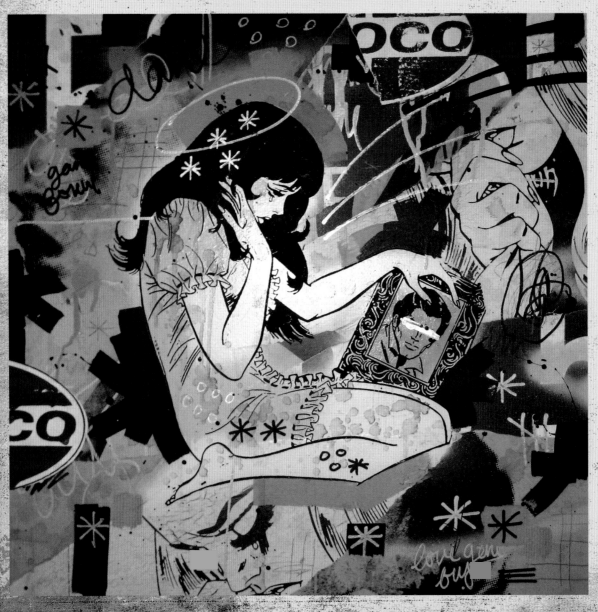

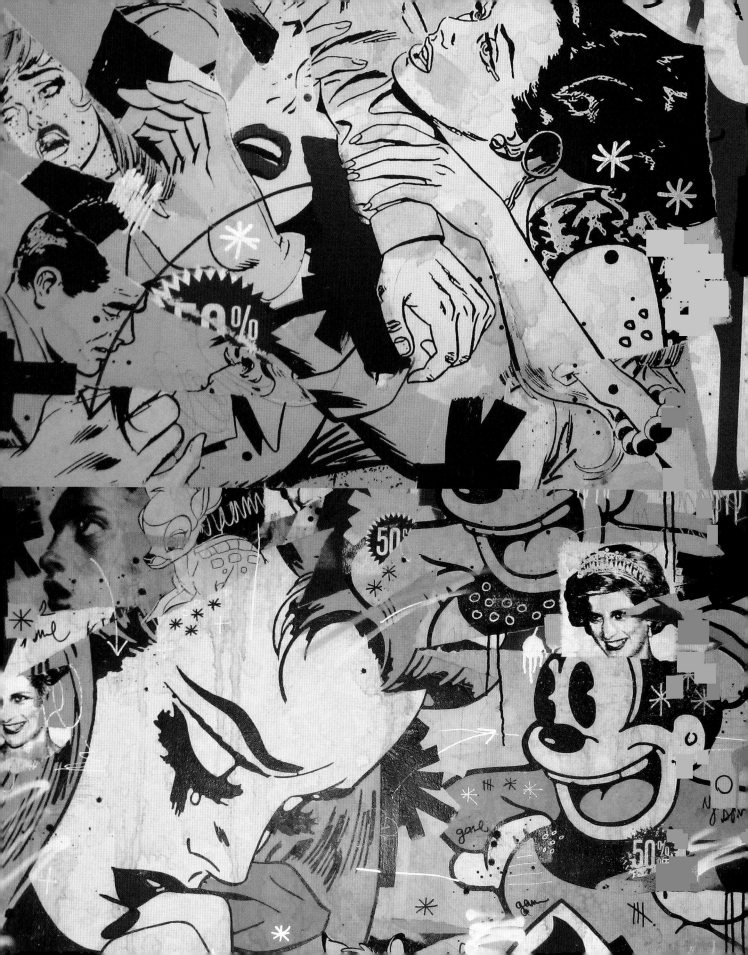

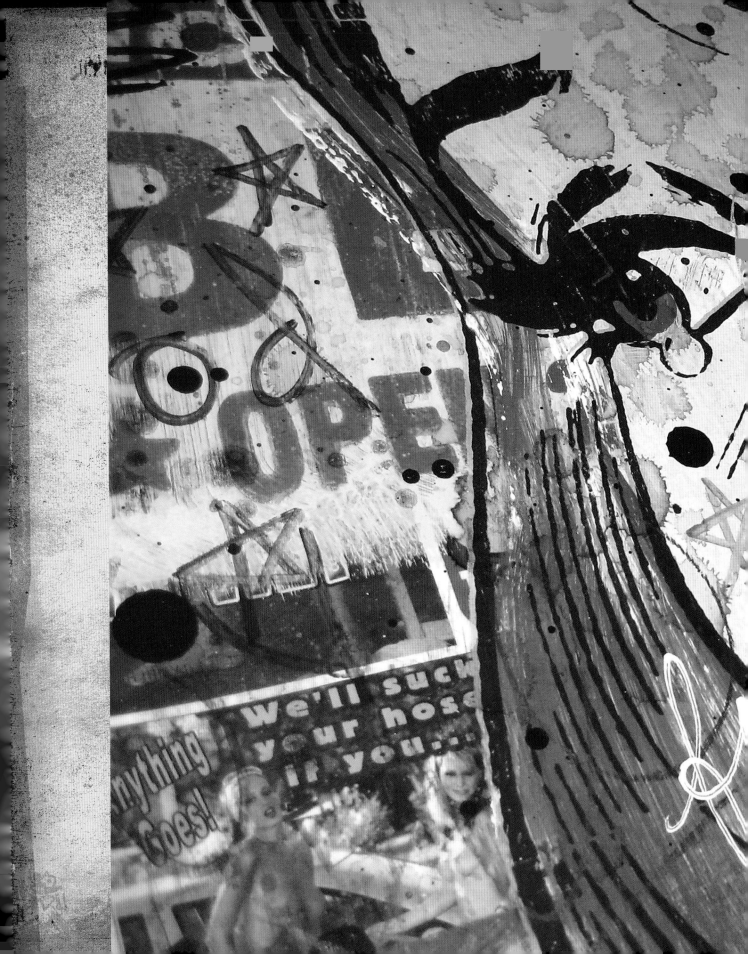

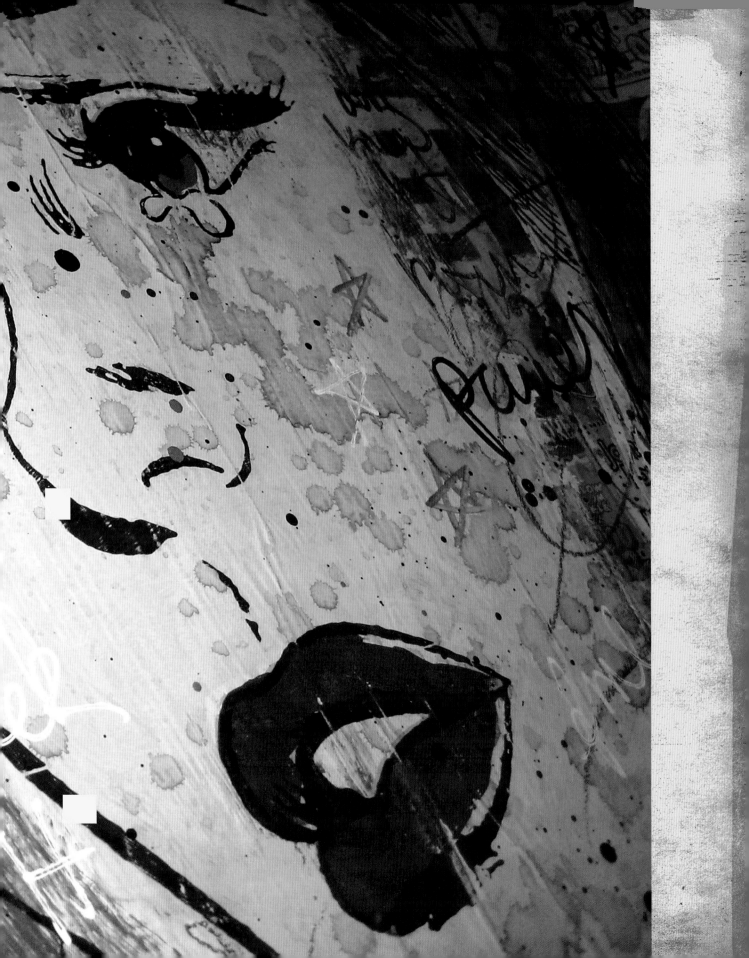

DAZE

Very few of prolific graffiti 'writers' who flourished during the 70's and 80's have survived the transition from street to studio. Chris 'Daze' Ellis is among those whose work has provided a powerful and continuing record of an exciting outlaw era of painting. Daze, more than any of the muralists, has successfully conveyed an ongoing message about the mean streets, a segment of the urban cultural experience ignored by more conventional painters. Many of his paintings and watercolors are peopled by characters who at once frighten and amuse. His street scenes are parties where artists, cops, hookers, pimps and musicians mingle. These cartoon-like figures are humorously drawn, but beneath the pleasantness is a more serious subtext. Daze was recognized early on as one of the masters of the graffiti movement. Since then, his work has taken on a new sophistication which depicts the excitement of the street and recreates the spontaneity of the subway paintings which were the direct precursors of the post pop phenomenon.

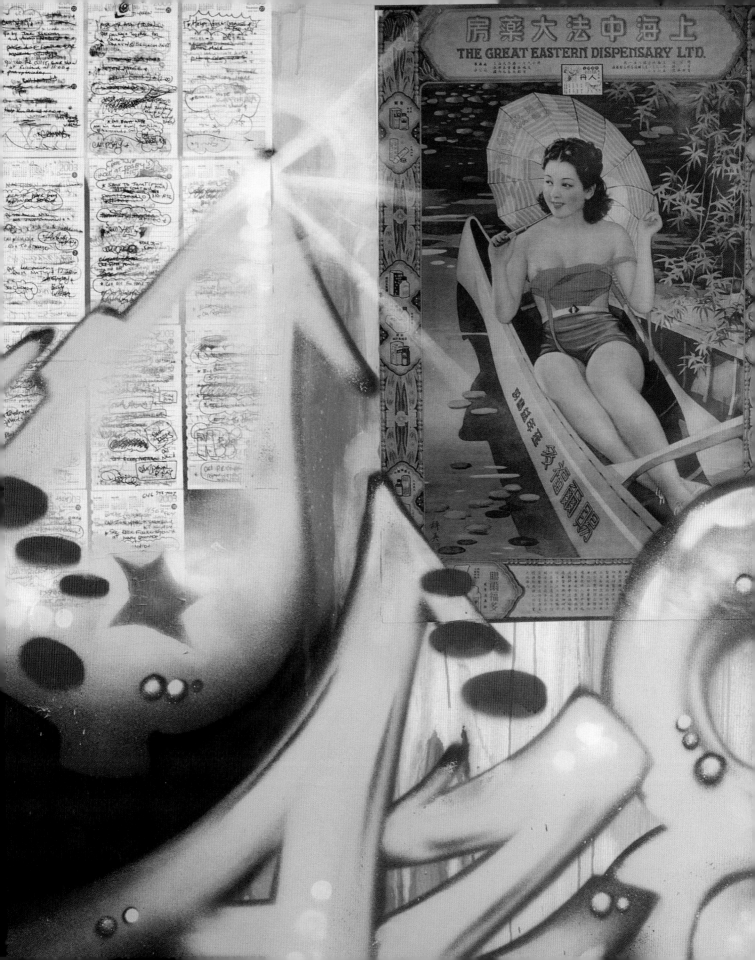

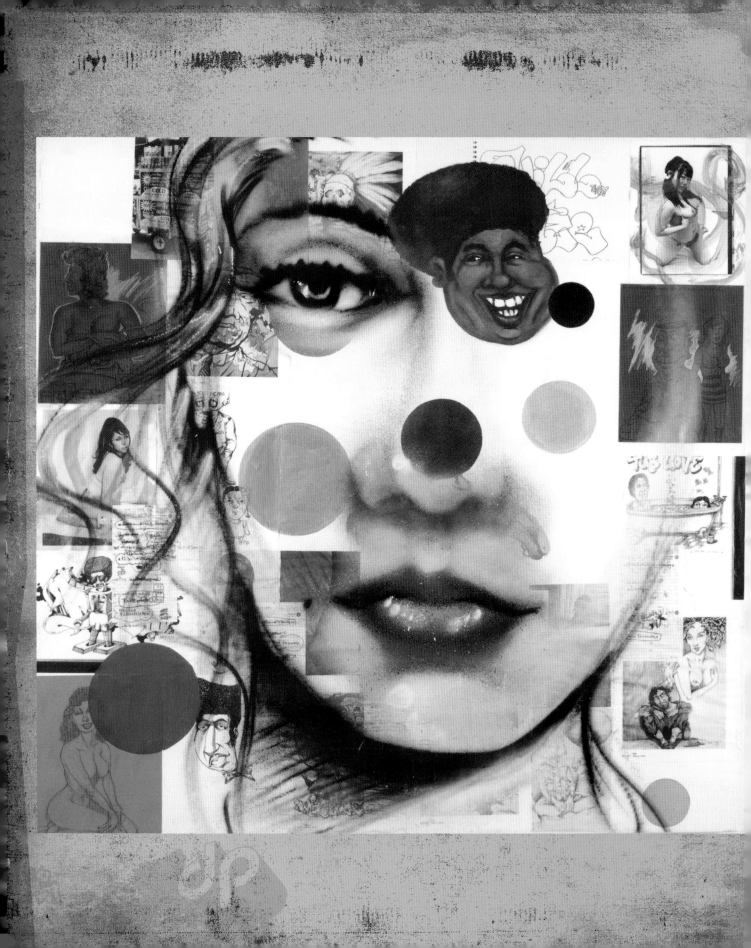

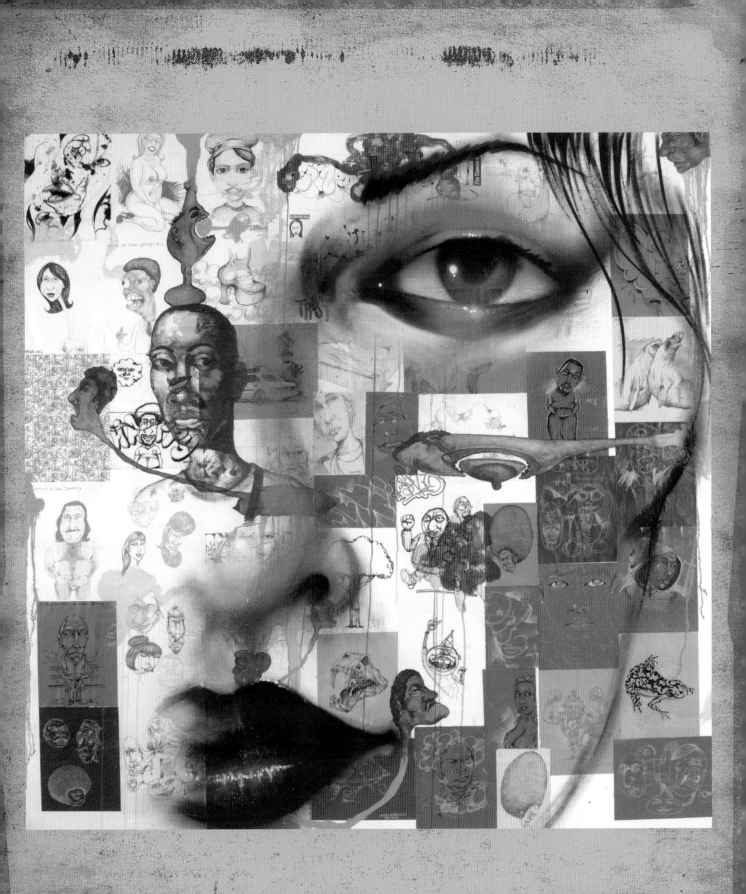

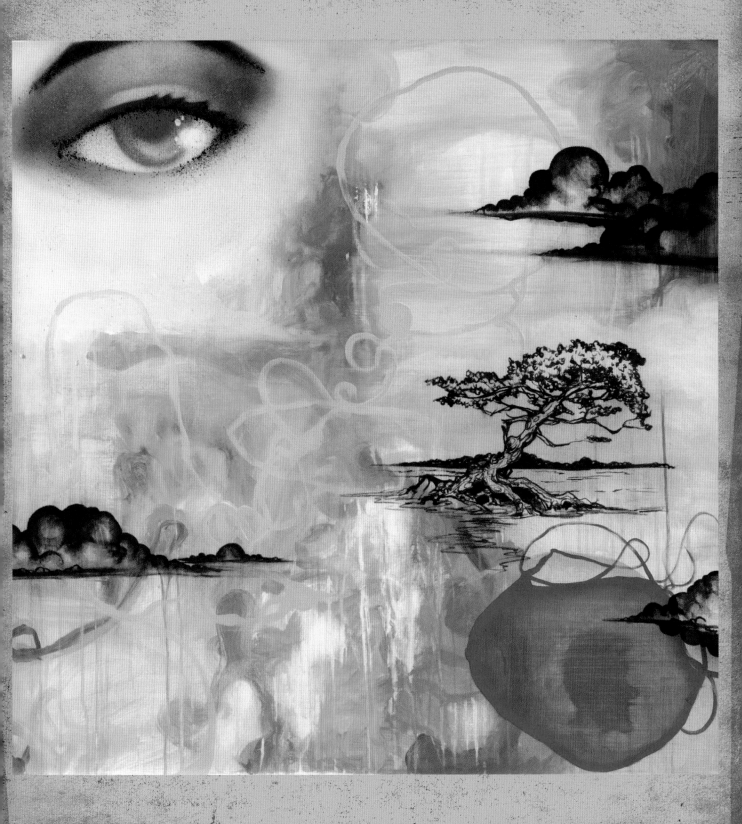

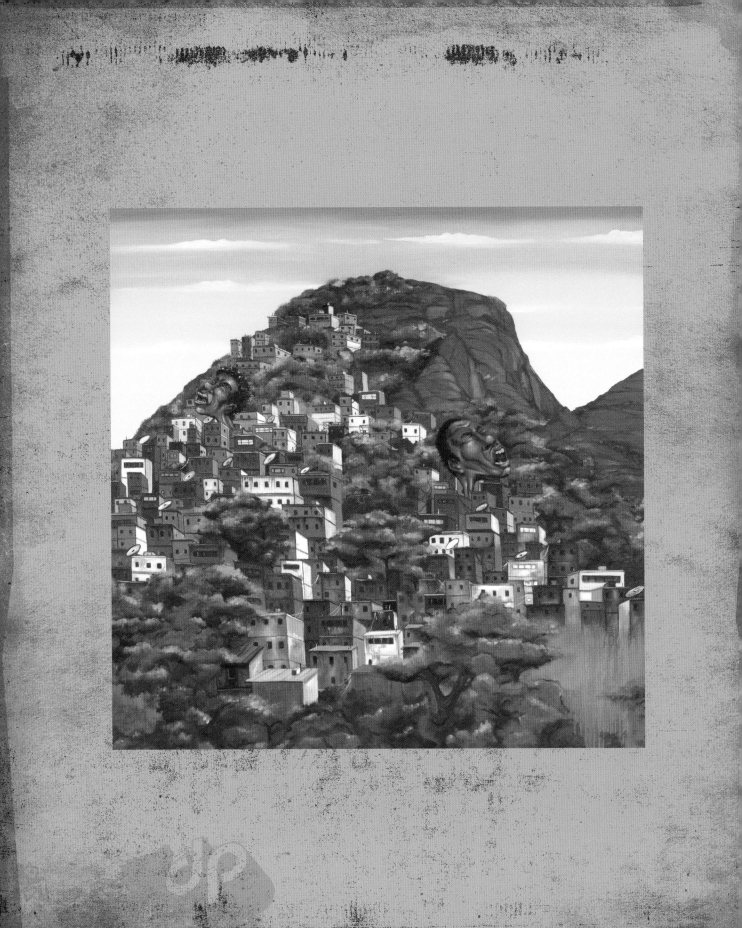

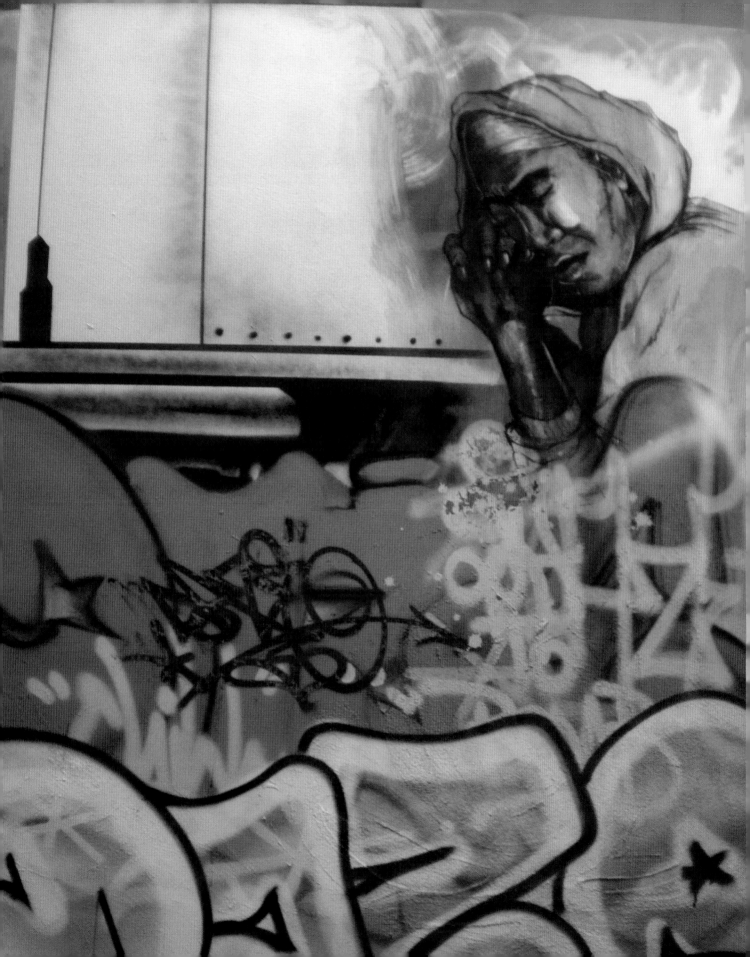

ENRIQUE MARTINEZ

"I guess all I can say about my work is that I like to think of myself as somewhat of a political cartoonist. Except my cartoons are sometimes sprawling lnadscapes, instead of boxes in a newspaper or magazine in the way that people normally think of political cartoons. But they do the same thing, which is to draw the viewers attention to a particular societal dilemma and offer a satirical punchline as a way of getting a point across. My point is that we should never passively accept the status quo when we feel there is some injustice being commited by government or religious leaders, or by one person to another. I hope to light a fire under the viewer and instigate some action by illustrating a "worst case scenario" or an amplified grotesque perspective of a certain issue...the descruction of the environment, war, power mongering, religious and political fanaticism...the effects of poverty...etc etc. I guess more than anything I just want to say "WAIT, look how crazy things have gotten! Lets not continue down this path, there must be a better way."

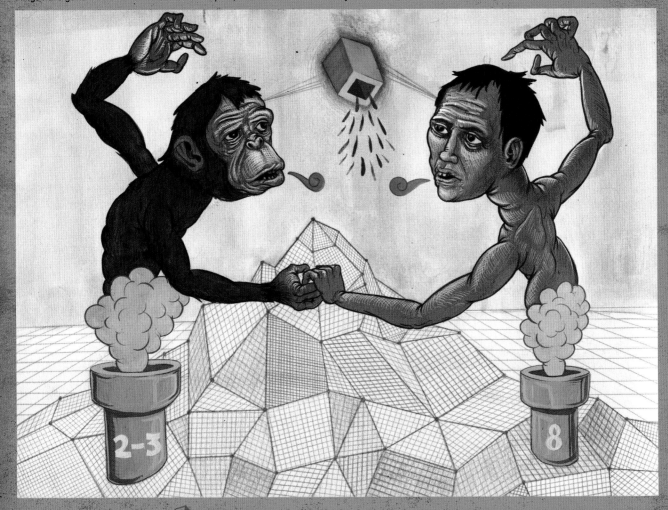

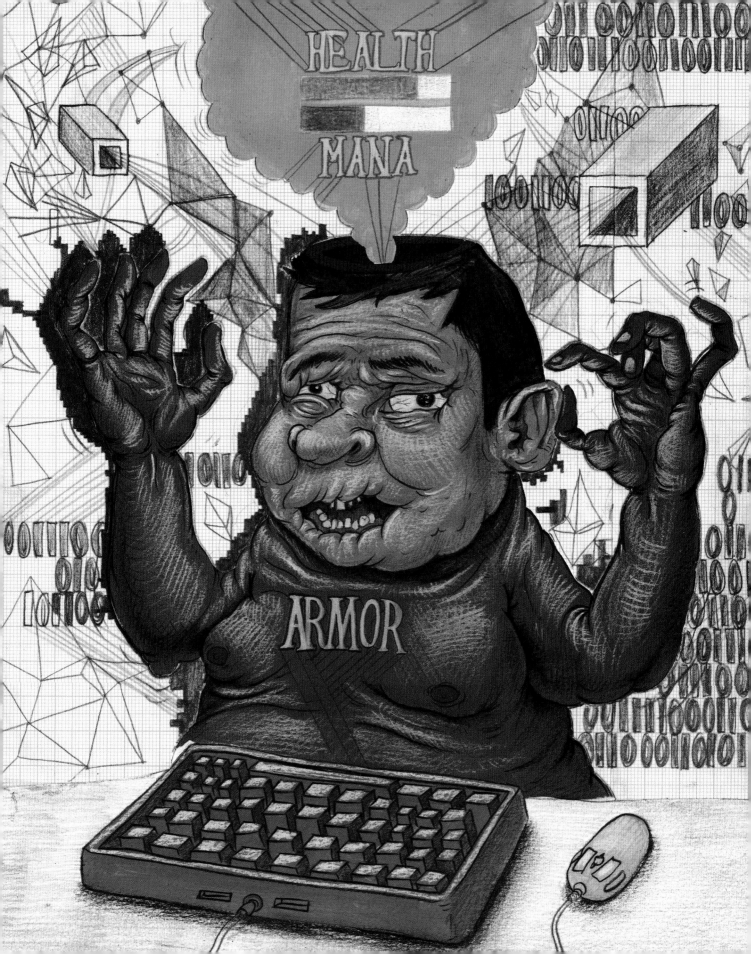

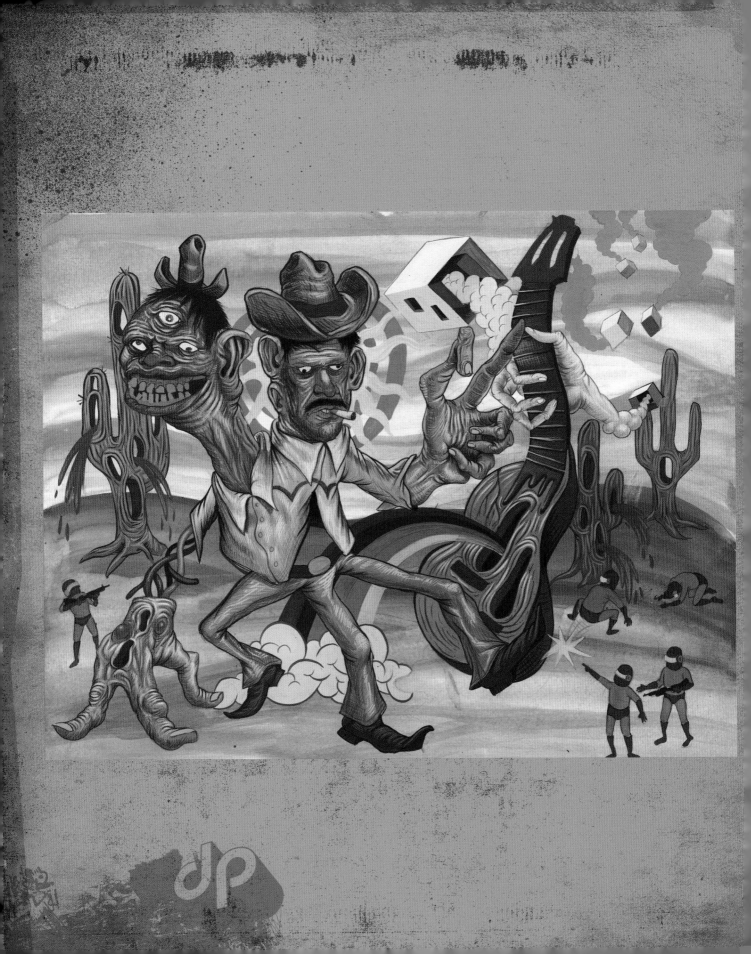

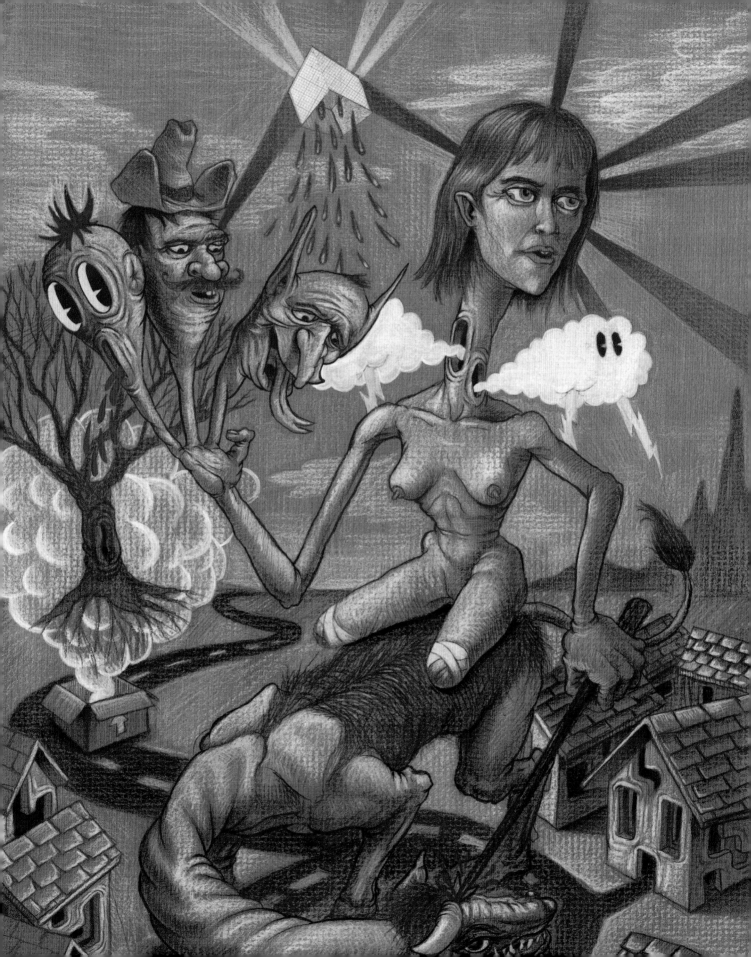

CERN YMI

SHOW DATES
NOV 22 – JAN 14

Cern began writing graffiti in the early nineties.
Diverse in his scope, he has created numerous collaborative murals with the YMI crew and artists around the world, and exhibited canvas and watercolor works in galleries around New York City and beyond.
Cern has been included in books such as Burning New York and Graffiti World. His unique blend of fantasy and realism blurs the lines between graffiti and fine art, and exhibits a technical mastery of his medium.

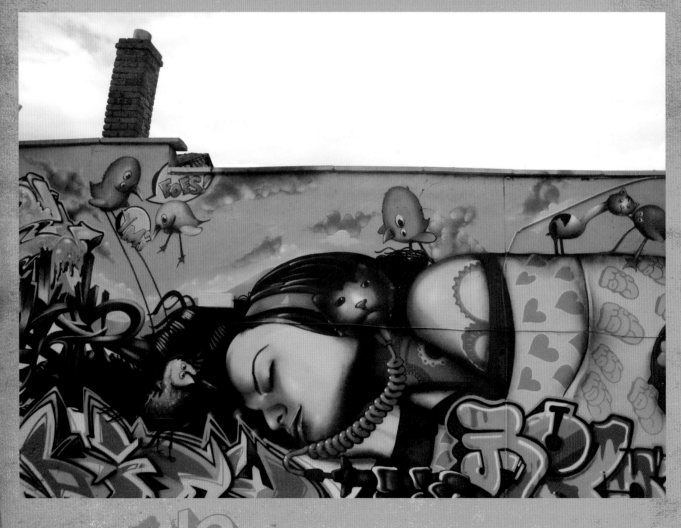

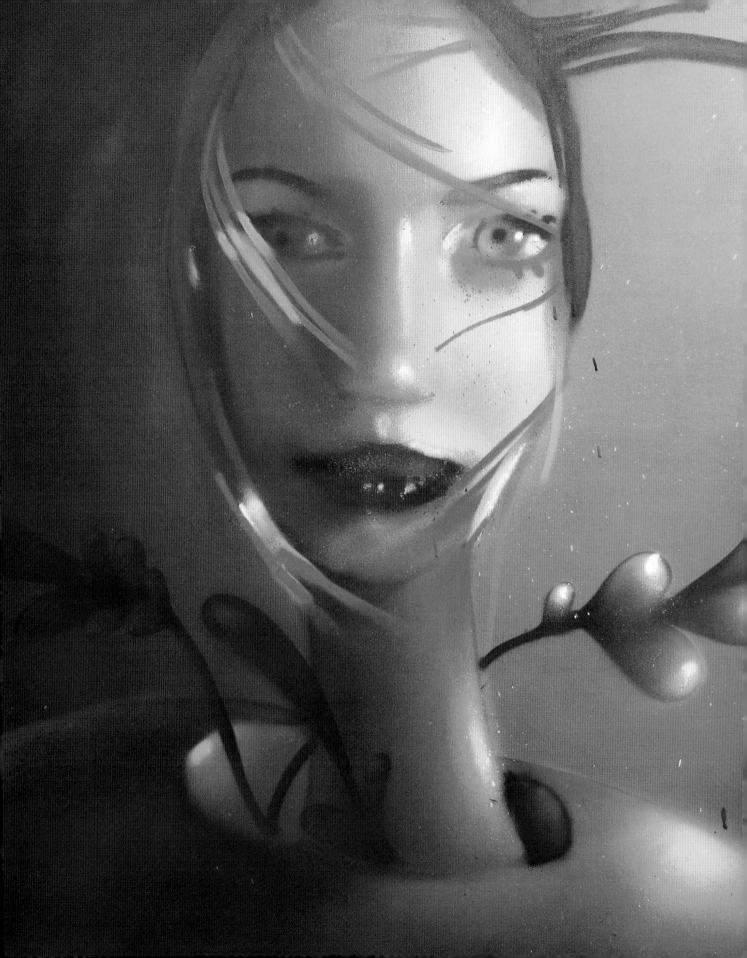

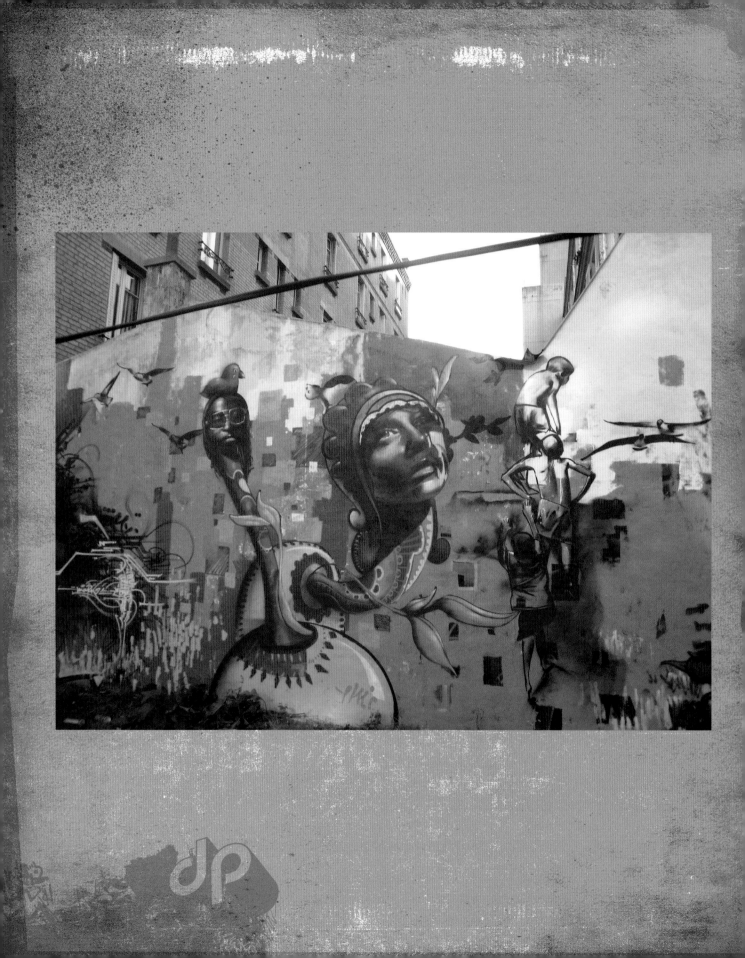

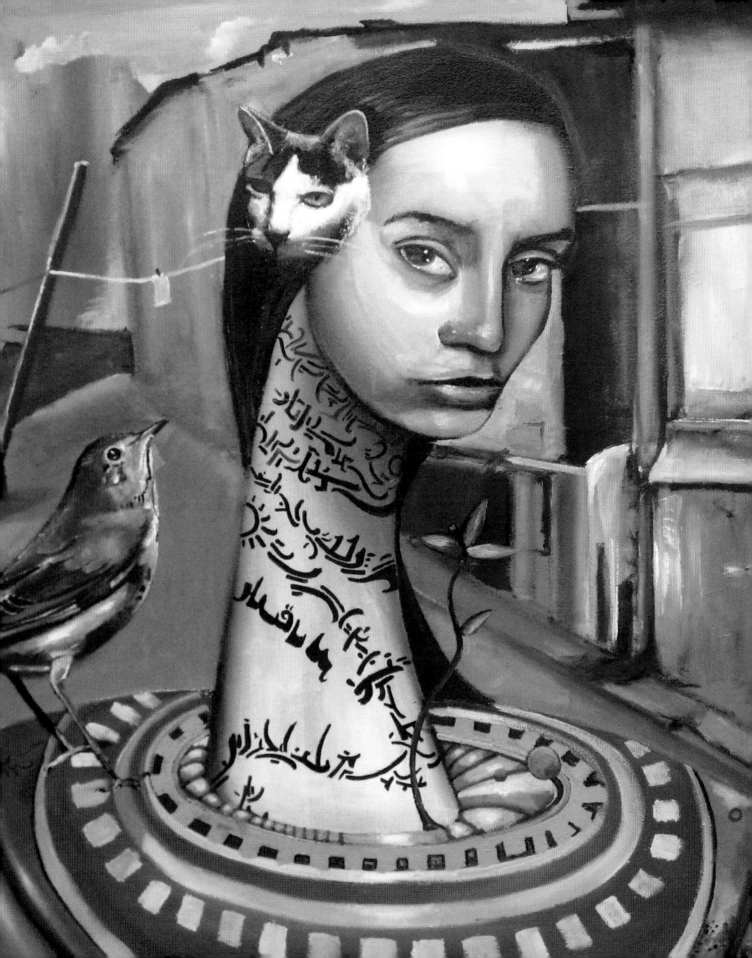

ALBERT REYES

Albert Reyes has been known to spit art on his hands and knees with a mouth full of beer in the middle of the street. He has also shown in a gallery along with a painting by Picasso. These same strange dualities and juxtapositions are highly prevalent in his work, which tackles both conceptual and graffiti art. Recognized for his ubiquitous "GIVE" tag, Albert has a distinctive artistic approach inspired not only by street art, comic books, and American pop culture; but also by contemporary and classical "high art". Reyes has exhibited worldwide. He has done album cover artwork for the band Le Rev and singer/songwriter Simone White. He has also appeared in the New York Times: Year In Ideas, Swindle, Chicano Art Magazine and appeared on Jimmy Kimmel Live, CW's Online Nation, and CNN.

WWW.PIMPLYWIMP.COM

BRAVO JETT

Following in the tradition of 60's pop artists, Bravo Jett has burst on the scene, juxtaposing advertising images from popular culture in his paintings. Using his meticulous blending technique often confused with airbrush, Jett puts his original stamp on the TV, brand images, and media messages that bombard our senses daily. His works both excite and entertain, while giving us a gripping landscape of character and color to capture and deliver their meaning.

WWW.BRAVOJETT.COM

CERN YMI

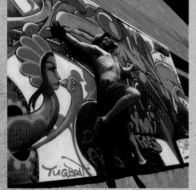

Cern began writing graffiti in the early nineties.
Diverse in his scope, he has created numerous collaborative murals with the YMI crew and artists around the world, and exhibited canvas and watercolor works in galleries around New York City and beyond. Cern has been included in books such as Burning New York and Graffiti World. His unique blend of fantasy and realism blurs the lines between graffiti and fine art, and exhibits a technical mastery of his medium.

WWW.YMICREW.COM

CHRIS "DAZE" ELLIS

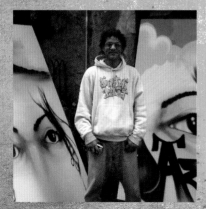

Very few of prolific graffiti 'writers' who flourished during the 70's and 80's have survived the transition from street to studio. Chris 'Daze' Ellis is among those whose work has provided a powerful and continuing record of an exciting outlaw era of painting. Daze, more than any of the muralists, has successfully conveyed an ongoing message about the mean streets, a segment of the urban cultural experience ignored by more conventional painters. Many of his paintings and watercolors are peopled by characters who at once frighten and amuse. His street scenes are parties where artists, cops, hookers, pimps and musicians mingle. These cartoon-like figures are humorously drawn, but beneath the pleasantness is a more serious subtext. Daze was recognized early on as one of the masters of the graffiti movement.

WWW.DAZEWORLD.COM

CHRIS STAIN

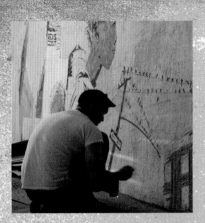

"I grew up in Baltimore in the 80's. Through books and movies I was introduced to NYC subway graffiti which sparked my interest in art, making it a viable means of self expression for myself. In high school I learned screen printing methods which would later aid me in the process of stenciling. I have always been sensitive to my surroundings and the struggles of common working people. With my work I hope, at best, to inspire compassion in people who hold positions of power to effect change in the lives of the less fortunate"

WWW.CHRISSTAIN.COM

DANIEL JOHNSTON

The award-winning documentary "The Devil and Daniel Johnston", a property of Sony Pictures Classics, opened to rave reviews on March 31st 2006, in both NY and LA. Running concurrently with the opening of the film was a body of Daniel's work at the Whitney Museum's Biennial exhibit! Much has also been written about the music of Daniel Johnston. And there is good reason; Daniel is one of the greatest songwriters of this or any other generation. Daniel's been playing his intensely unique songs since he was a young teenager and garnering fans all over the world, including such notables as Kurt Cobain, David Bowie, Pete Townshend, Matt Groening (creator of "The Simpsons"), Jad Fair, Lou Reed and Maureen Tucker. Unfortunately, much less has been written about his artwork. That, however, is beginning to change. Over the last few years, Daniel's drawings are showing in larger and larger galleries and prices for his work are climbing steadily higher. What is astounding about Daniel's work is the fact that he is an absolute unending wellspring of creativity, the likes of which I have never witnessed before. No creative blocks here… what he thinks and feels gushes out on to the paper, or into a song.

WWW.HIHOWAREYOU.COM

DENNIS MCNETT

Dennis McNett was born in 1972 and grew up in Virginia Beach, VA. He moved to New York in 2001. He has been carving the hell out of surly block prints for over 17 years. Some of his encouragement as a young kid came from his blind grandfather, who told him over and over again that his drawings were good. Later influences came from the raw high-energy graphics pouring out of the 80's skateboard and punk rock scene. Dennis has been fortunate enough to show work both nationally and internationally, design board graphics for Anti-Hero skateboards, design shoes for Vans, participate in the Deitch Artparade, and do collaborations with Cannonball Press. His work has been featured in The New York Times, Juxtapoz magazine, Thrasher and Complex Magazine. He holds an MFA from Pratt Institute, where he now teaches as a printmaking professor at the graduate and undergraduate level. He wants to live until he dies. Breathing is good.

WWW.HOWLINGPRINT.COM

ENRIQUE MARTINEZ

Enrique Martinez is an artist with a limitless imagination. His sense of wonder before the follies of mankind (and alienkind as well) literally knows no bounds. Moreover, as a phenomenally gifted draftsman and painter, he has the all-too-rare ability to materialize the phantasmatic fears, confusions, obsessions, and contradictions of our contemporary world. It is a universe in which all apparent victories are Pyrrhic. Lust and aggression culminate in a state of anxious melancholy rather than one of satisfaction and release. Martinez weaves together an improbable cast of heroes, villains, aliens, common folk, grotesque giant mutants, malignant polyps that defy precise categorization, and other sundry composite creatures that are drawn from a myriad of sources in both high art and popular culture. While a few of them subsist in an all-too solitary confinement, most pour out onto the page as if they had been jettisoned from a Surreal floodgate. Martinez sensibilities parallel those of R. Crumb. His penchant for creating hybrid monsters recalls Hieronymus Bosch. Martinez utilizes imagery from José Guadalupe Posada and Day of the Dead, and he also mixes fine art and pop and consumer culture like Enrique Chagoya. Enrique was born in El Paso, TX and now living in San Antonio, TX.

WWW.FLICKR.COM/KIQUE

GHOST

One of New Yorks most celebrated Graffiti artists showcased at Dirtypilot.com Ghost is one of the most intriguing and respected New York City Graffiti artists who has taken the successful leap into the fine art world and creating the buzz at Dirtypilot.com. A NYC subway era legend, Ghost developed his unique formal technique through his involvement with the NYC Graffiti movement where he became recognized for his original style and vibrant color combinations, along with his sense of satire.

WWW.COUSINFRANK.COM

GREG GOSSEL

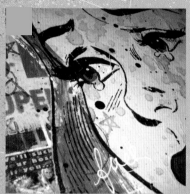

Greg Gossel was born in 1982 in western Wisconsin. With a background in design, his work is an expressive interplay of many diverse words, images, and gestures. Gossel's multi-layered work illustrates a visual history of change and process throughout each piece. His work has been exhibited throughout the U.S. and abroad, including San Francisco, New York, Los Angeles, and London. He currently resides in Minneapolis, Minnesota.

WWW.GREGGOSSEL.COM

JUSTIN BUA

Since the early 1990's, BUA has been making a mark in the art world with his unique style of Distorted Urban Realism, spearheading a new genre of art. Born in 1968 in NYC's untamed Upper West Side and raised between Manhattan and East Flatbush, Brooklyn, BUA was fascinated by the raw, visceral street life of the city. He attended the Fiorello H. LaGuardia High School of Music and Performing Arts and complemented his education on the streets by writing graffiti and performing worldwide with breakdancing crews. BUA went on to the Art Center College of Design in Pasadena, California where he earned a B.F.A. in Illustration. He currently lives in Los Angeles, where he teaches at the University of Southern California and continues to be a leading innovator in the fine art and commercial art worlds. For more information visit

WWW.JUSTINBUA.COM

KIME BUZZELLI

Kime Buzzelli found early inspiration in her collection of "paper dolls," constantly creating costumes and dramas for them.When she began painting, this "narrative" of fashion informed her work, painting women with a dialogue designed from an addiction to clothing. This is the basis of Buzzelli's work today. Known for her paintings of wayward nymphs, broken-hearted waifs and androgynous party girls, Kime explores the pain, joy, and integration of fashion in the feminine psyche. After studying fashion illustration at Parson's School of Design in New York, Buzzelli earned two degrees in painting and art education from Ohio State University. Since then, Kime has been exhibiting her work throughout the world in such esteemed galleries worldwide.

WWW.KIMEBUZZELLI.COM

MICHAEL KRUEGER

Michael Krueger is searching for the extraordinary in everyday life and looking at history and memento, as means to better understand a world that is built on past events and memories. Personal and biographical in nature, Krueger mines a retrievable past in the form of high school journals, tardy slips, party maps, and concert posters. Michael is interested in reexamining this time in his life to better understand the events that helped shape it. This time period shortly after the Vietnam War and the waning years of the Cold War is a strange and psychologically complex period in U.S. history. The Heavy Metal movement that grew out of a post-Vietnam War era obsession with decadence, death and nihilism continues to fascinate Krueger.

WWW.MICHAELKRUEGER.US

PAPERMONSTER

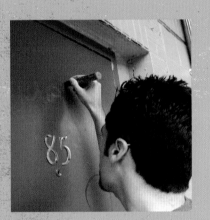

PaperMonster is a stencil graffiti artist who's vivid and intricate pieces explore the beauty behind the eyes and subtle facial expressions of women. Upon hearing "PaperMonster" one imagines very masculine qualities yet one is astonished to find an ironic contrast to the name full of color and beauty. Born in Puerto Rico, PaperMonster incorporates stencil and pasting techniques to create unique pieces of art. His work can be found on many surfaces as he combines pop culture icons, Asian typography, patterns and texture to present vibrant emotions and stories. PaperMonster's stencil art pieces allow the audience to take his creations at pure face value or explore deeper into each piece. His art has been featured in magazines and exhibitions throughout the world such as the Melbourne Stencil Festival (Australia 2008).

WWW.PAPERMONSTER.ORG

STEPHEN TOMPKIN

Stephen Tompkins' work has appeared in many exhibitions throughout the US and in Europe beginning in the mid 1990s, with a collaboration exhibition with Daniel Johnston. His work includes painting, drawing, sculpture, soundworks, and stream-of-consciousness animations, some consisting of hundreds of drawings each. His idiosyncratic style, that cuts across numerous mediums, reveals a methodical scrambling of a personal cartoon memoir and comic archaeology. His early interest in art was spawned by his studies in philosophy and existential psychology. He has a BA in Philosophy and a "near-Masters" degree in Philosophy with a background in Phenomenology and Semiotics. Brad Martin, contributing writer to Juxtapoz recently wrote that Stephen's work is "like a Merry Melodies hit and run or some boiling hell for all the forgotten toons."

WWW.STEPHENTOMPKINS.COM

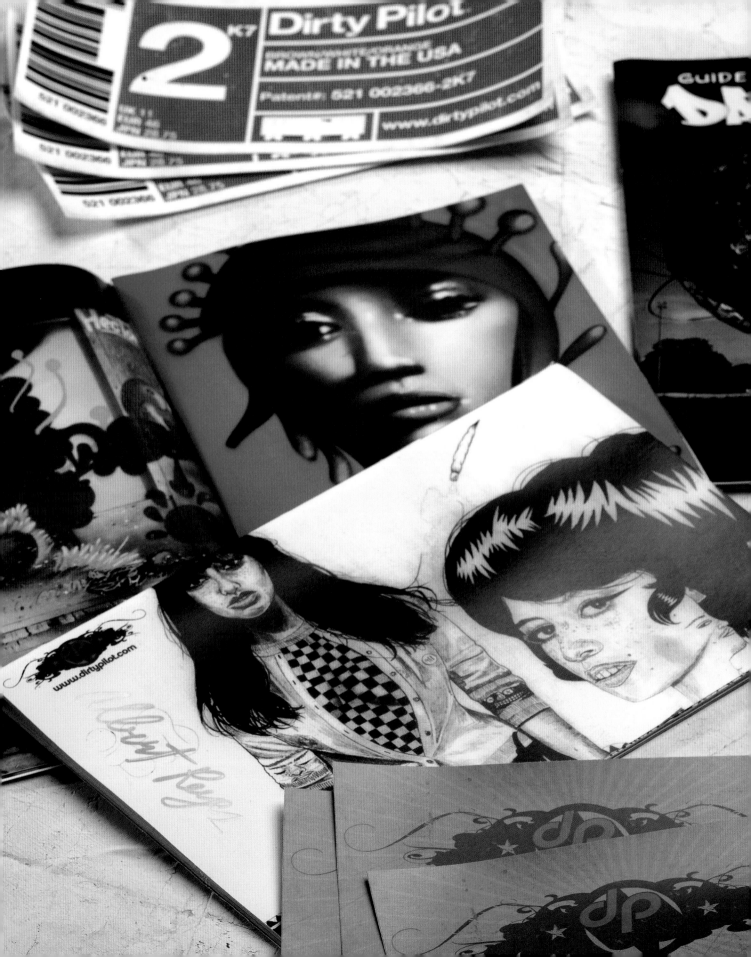

DIRTYPILOT.COM

A SURVEY OF GRAFFITI, STREET AND URBAN ART

YEAR ONE REWIND

Co-Published by
LAST GASP/DIRTYPILOT.COM

Designed by
ANT VENTOLIERI

Production
BORTMAN DESIGN GROUP INC.

Advisor
DON GOEDE

SPECIAL THANKS
Albert Reyes, Bravo Jett, Cern YMI, Chris "Daze" Ellis,
Chris Stain, Daniel Johnston, Dick Johnston
Dennis McNett, Enrique Martinez, Ewok 5MH, Ghost,
Greg Gossel, Justin Bua, Kime Buzzelli, Michael Krueger,
PaperMonster, Stephen Tompkins,
Colin Turner, Linda Hobbs, Don Goede,
and all the artists who pitched in along the way.

ISBN-13: 978-0-86719-712-9
Printed in China

Cover Image: Cern YMI Titled "Lit" 36"x 36", spraypaint on canvas, 2007.